BRISTOL COUNTRY BUSES

MIKE WALKER

This brief history of Bristol's country buses is dedicated to the thousands of employees responsible for providing Bristol's country bus services, many of whom devoted their entire working lives to this end. Be they drivers or conductors, inspectors or supervisory staff, maintenance or clerical workers, they all had one purpose in their employment: to provide the best possible service for the travelling public. In my twenty-six-year career in the operational side of public transport, over half of them were spent being responsible for Bristol country bus services, and so this volume has a special place in my heart.

First published 2017

Amberley Publishing
The Hill, Stroud
Gloucestershire, GL5 4EP

www.amberley-books.com

Copyright © Mike Walker, 2017

The right of Mike Walker to be identified as the Author of this work has been asserted in accordance with the Copyrights, Designs and Patents Act 1988.

ISBN 978 1 4456 5269 6 (print)
ISBN 978 1 4456 5270 2 (ebook)

All rights reserved. No part of this book may be reprinted or reproduced or utilised in any form or by any electronic, mechanical or other means, now known or hereafter invented, including photocopying and recording, or in any information storage or retrieval system, without the permission in writing from the Publishers.

British Library Cataloguing in Publication Data.
A catalogue record for this book is available from the British Library.

Typeset in 9.5pt on 11pt Celeste.
Typesetting by Amberley Publishing.
Printed in the UK.

Acknowledgements

I would like to express my sincere thanks to everyone who has assisted in the preparation of this book. A number of people generously provided material that was of use in the final text, and Peter Davey, Stephen Dowle, Graham Jones, Allan Macfarlane, Alan Peters, Barbara Rex and Dave Withers are thanked for carefully checking some or all of the text for content and/or accuracy. However, if errors persist, then I recognise that they are solely my responsibility.

In order to augment my own modest collection of photographs I have generously been allowed access to the collections of others in order to make my final selection. In this regard, Deryck Ball, Simon Butler, Peter Davey, Geoff Gould, Graham Jones, Geoff Lusher, Mike Mogridge, Phil Sposito and Alan Walker are to be particularly thanked, as is Dave Withers for allowing access to the Bristol Vintage Bus Group Collection (credited as BVBG). I am also grateful to The Omnibus Society for access to their timetable library and permission to publish photographs from their archive.

Where photographs are credited to a collection, it is recognised that the collection owner may not be the copyright owner, and I would like to offer my apologies if the reader is affected in this way.

I have tried to illustrate a variety of vehicles, locations and routes to reflect Bristol's country buses, but, certainly until the 1960s, many of the photographs were taken in the same central Bristol location, and this reflects the limited availability of other photographs of this time.

The preparation of this brief examination of Bristol Country Buses has been a pleasure and I hope that you, the reader, take as much enjoyment from reading this volume as I have in preparing it.

Mike Walker
Wells
Somerset
December 2016

Introduction

This volume is not intended as a complete history of the country bus services from Bristol between the end of the Second World War in 1945 and the deregulation of bus services in 1986; instead, it offers the reader a flavour of the destinations, vehicles, working practices and fortunes of the Bristol country bus services during that period. It covers the growth in passenger traffic after the end of the war and the steady decline, particularly in rural services, brought about by the rise in car ownership, the increase in home entertainment and the rise in disposable income, as well as the increase in sophistication of the vehicles used and the inevitable loss of conductors, even on the high-frequency interurban services. These milestones are described both in the writing and the photographs.

Readers wishing to delve deeper into the history of Bristol's country bus services are recommended to refer to some of the publications referenced in the bibliography.

The Years between the War and Deregulation

As a maritime city, Bristol traded with the world: additionally, an internet search tells us that 'Bristol was a major hub of the stage coach network', and that in 1830 a

> light van for passengers left The Full Moon Public House for Olveston [outside of the city boundary to the north] every Tuesday, Thursday and Saturday at 5 in the evening, and a van for passengers and parcels left on Mondays, Wednesdays and Saturdays for Thornbury [also to the north of the city] at the same hour.

It is also noted that 'by the end of the century no less than ten carriers operated out of the Full Moon'. A history of Long Ashton, to the south of the city, reveals that 'a horse drawn bus ran from Redcliffe Street, Bristol, to The Bird In Hand, Long Ashton, several times a week in the late nineteenth century'.

Horse trams were first introduced for city transport in 1875 and by 1908 the network had reached its maximum size and had been electrified. By this time a number of horse bus feeder services were in operation from outlying towns and villages to connect with the tramway network at the outer terminals. The first motor buses were introduced by the Bristol Tramways & Carriage Co. Ltd in 1906, and certainly the country tram feeder service to Saltford (between Bristol and Bath) was an early beneficiary from such an innovation. By 1908 the company was building its own motor buses, and further expansions both within the city and outside were operated by this type of bus.

For a long time the company did not allocate route numbers to the city tram network (though for a short time the numbers 1–17 were allocated and shown), although their first motor bus route within the city was numbered 18. New motor bus routes were numbered sequentially at their introduction and included a route from the tram terminus at Staple Hill (east Bristol) to Pucklechurch, Parkfield and Dyrham (19A), from Prince Street (central Bristol) southwards to Axbridge, Highbridge and Bridgwater (23), Axbridge and Cheddar (23A), Weston-super-Mare (24) and Clevedon (25), the Chew Valley, Winford, Blagdon and Bishop Sutton (38/39) and north to Wotton-under-Edge and Gloucester (26), Frampton Cotterell (26A), Berkeley, Gloucester and Cheltenham (29), Thornbury (30), north-east and east to Chipping Sodbury, Malmesbury and Swindon (31), Chipping Sodbury, Tetbury and Cirencester (32), Keynsham and Bath (33) and Marshfield and Chippenham (35). Even where some of these services were introduced before the First World War, a number of them were suspended during hostilities because of the shortage of manpower due to members of staff 'joining the Colours'.

Between the two World Wars, the company set up branches throughout its expanding operating area, and the first evidence of local services thus operated is service 40, a town service in Weston-super-Mare. The establishment of branches and depots at other locations also allowed the company to start new links by establishing services that radiated out from the branch towns.

Just before the Second World War an agreement was reached with Bristol Corporation; this resulted in the 1937 Bristol Transport Act and the formation of a separate company with equal shareholding, and the establishment of the boundary for what were then to be termed Bristol City Services, broadly following the boundary of the city and county of Bristol. Those services operating from Bristol, but outside of the scope of this Act, became country services. The Bristol city trams were gradually replaced by motor buses, although a small number of tram routes continued into the Second World War as a means of saving precious fuel resources, only being terminated when a stray German bomb severed the power cables. One immediate effect of the Joint Services Agreement was the need to identify, for accounting purposes, the new Bristol Joint Services bus fleet; this was achieved by adding the prefix 'C' to the fleet number. A complicated accounting procedure was then introduced to record city (BJS) mileage – and therefore costs and revenue – operated by country buses and vice versa for city (BJS) buses so as to 'balance the books' of the two separate companies, although both city and country services were operated from the same Bristol depots.

For the first time, therefore, this 1937 Agreement allowed for the identification of the city and country bus fleets, as generally speaking, up until this date, depots in the city could allocate buses under their control to either city or country routes. The country routes mostly terminated close to or around the Tramways Centre, although a small number of routes still terminated at outlying tram terminals for city connections.

Between the wars the company also acquired three Bristol-based operators, together with their services. Two of them, Russetts ('Pioneer') and Greyhound had a small group of city and country routes, many of which duplicated the Tramway's own services, while Bence, based at Hanham at the eastern edge of the city, operated a network of routes that connected Hanham with other Bristol suburbs, such as Bitton, Kingswood, Longwell Green and Staple Hill. This orbital network of Hanham-based local services, outside of the control of BJS, continued to be operated by the Tramways Co. from the former Bence depot at Hanham.

It was in this form that the company entered the Second World War. With the high-profile docks, both in the city and to the west at Avonmouth, and the aero factories at Filton and Patchway to the north, the city was subjected to much bombing, which had a disastrous effect on both the vehicles and premises. Despite bus driving remaining a reserved occupation, many of the company's staff left to join the forces, resulting in the use of auxiliary conductors (who were employed elsewhere but assisted the regular conductor when travelling to and from their workplace) and female drivers. On the vehicle front, the company bought a number of secondhand vehicles, as well as borrowing a number of double-deckers from other operators.

Prior to the outbreak of the war, the company had ceased to be independent and a controlling interest had been acquired by the Thomas Tilling organisation; the Tramways Co. was placed under the control of Western National. During the war years the livery of blue and white (with red wheels) was replaced with blue and grey, grey or khaki, with the small number of new vehicles allocated by the Ministry of Supply being delivered in the latter colour. The company's bus manufacturing plant, which had

been supplying buses and coaches since 1908, was turned over to war work. Towards the end of the war a new – Tilling standard – livery of green and cream was gradually introduced.

By 1946, with the war years behind it, the company found itself in a position to reintroduce those services that had been suspended during hostilities and increase frequencies on others. The Central Repair Works, at Lawrence Hill in Bristol, undertook the repair and refurbishment of those vehicles that had sustained war damage, and new vehicles were eventually assembled at the company's chassis plant and body works.

By 1948, with the nationalisation of both the railways and the Tilling group, bus/train inter-availability became a feature of the information shown in bus timetables. By 1949 advertisements were appearing in timetable booklets to the effect that a limited number of vehicles were now available for private hire, and the express coach network from Bristol was re-introduced, having been suspended during the war so as to save fuel. In May 1950 the Tramways Co. took over the services and vehicles of the Red & White Co. in Stroud in exchange for the Tramways Co.'s operation in the Forest of Dean, and from that date a new service, numbered 400, was introduced between Stroud and Bristol. On the same date the services and vehicles of Western National at Stroud were also taken over.

At the end of 1950 the company acquired the last independent bus operator running into the city. Dundry Pioneer had linked the city with the village of Dundry, high on the hills to the south of the city, and their route was incorporated into the Tramways' own service to that village.

There had been a number of Bristol depot changes following the war, with the Bedminster (south Bristol) and Horfield (north Bristol) depots closing and new buildings being opened (after being used for war work) at Winterstoke Road (south Bristol) and Muller Road (north Bristol). These, and other Bristol city depots, continued to operate the country services, albeit with some of them jointly worked with the branch depot at the opposite end of the route. By this time country routes were operated by a variety of mostly Bristol-built buses, with single-deckers of the B-, D-, J-, and L-type seating around thirty to thirty-five passengers, and G- and K-type double-deckers seating either fifty-six or fifty-nine (highbridge) or fifty-five (lowbridge). It should also be noted that all of the company's vehicles were at that time operated by a crew of two: the driver and the conductor.

At around this time legislation affecting the construction and use of buses and coaches was modified, allowing extra width and length, and the company's bus building plant adapted their existing single-deck chassis while introducing a revised K-type double-decker, the KS (retaining the old width) and KSW. These were buses that in highbridge form seated sixty passengers in their updated aluminium-framed Eastern Coach Works body. The Tramways Co. took early batches of both chassis types with Bristol's own six-cylinder diesel engine, and they found ready homes on the long trunk routes from Bristol south to Bridgwater (23), north to Gloucester and Cheltenham (29), and east to Swindon (31), services on which through passengers could be expected to spend in excess of two hours.

In 1949 the chassis building plant had produced a prototype low double-decker chassis that, due to a lowered frame and a patented transmission, was able to achieve the same height as the lowbridge double-decker but without the disadvantage of the sunken, off-set gangway on the top deck. The first prototype was put into operation in the city as part of the BJS fleet, but was also demonstrated on a number of country routes. The mechanical layout of the prototype was complicated but by 1953 the design had been simplified, and one of six pre-production models was put into service on country route 27 (Bristol to Wells, Glastonbury and Street). Although the country fleet had received a small number of the revised KSW types with traditional lowbridge bodywork in the previous year, this new LD-type (or 'Lodekka') was soon to become the standard low-height bus for country services until the cessation of deliveries of the last FLF forward-entrance seventy-seat Lodekka buses some thirteen years later. The traditional normal-height KSW type continued to be ordered, however, although the country services standard called for Gardner engines, five-speed gearboxes (which enabled a higher maximum speed for cruising on country roads), passenger heaters and conductor-operated rear-platform doors.

Another noteworthy prototype, an underfloor-engined single-deck bus, was built in 1950, and, when perfected, the first production models of this LS ('light saloon') entered service in 1953. With the change of dimensions earlier authorised and the fitting of a set-back front axle, the seating capacity of this type of bus could be up to forty-five, and the bus was easily adapted for one-person operation; however, such conversions to these buses were not generally made by the company until 1958 or later. One-person operation of certain country services was agreed with the trade union at this time, but only if, after removal of the conductors, the services concerned were still not profitable. In addition to the underfloor-engined buses by then in service (including a small number of the LS replacement bus, the MW), a small number of front-engined Bristol L-type saloons were converted to forward entrance for this purpose, including a number of dual-doorway buses swapped with Bristol Joint Services for rear-entrance buses. Some of the earliest Bristol country services to lose their conductors were those to Dundry and the Chew Valley.

In 1957 the company was renamed Bristol Omnibus Co., and in September 1958 the biggest change to country services from Bristol came with the opening of a purpose-built country bus and coach station at Whitson Street, on the site of a former Tramway depot (coincidentally, close to the Full Moon public house, mentioned at the beginning of this brief history). Not only were all of the Bristol terminating country services brought under the one roof, along with the express coach services, they were now operated from a new depot here and the crews and buses were transferred from the city depots to this new operation. This site was soon renamed as the Marlborough Street Country Bus and Coach Station.

The depot allocation at that time shows fifty-nine single-deck buses, consisting of Bristol J- and L-types (although the J-types would last barely a further year, by which time their chassis were well over twenty years old) and underfloor-engined Bristol LS (and new MW) forty-five seaters. In addition, Lawrence Hill depot retained seventeen

country single-deckers and twenty-one double-deckers, the latter being K-, KS-, KSW- and LD-types. Of note is that the one-person-operated single-deckers were based at Lawrence Hill and continued to be so for many years: in fact, when there were a number of one-person-operator driving rosters at Marlborough Street (as Whitson Street became known) some years later, they were numbered sequentially as they were introduced; OMO 1 was Lawrence Hill based, although crewed by Marlborough Street drivers.

A small number of country service buses continued to be based at other Bristol depots, and a number of peak hour workings at each of these depots often operated on both city and country routes.

By 1960 one-person operation of services was gradually extended, but for the more heavily used country services Marlborough Street received new sixty- and seventy-seat Bristol flat-floor forward-entrance double-deckers, and these were placed in service on the busy Weston-super-Mare (24), Clevedon (25) and Bath (33) routes, all of which carried a great deal of intermediate traffic in addition to the passengers journeying end to end.

By this time the company had replaced the 'bell punch' ticket machines, and their cumbersome rack of tickets, with 'Setright' ticket machines, which sped up both ticket issuing and accounting. The machine was able to print and record any fare value, and the conductor was able to calculate the total daily cash from the figures recorded on the relevant register values for each journey and for his day's work.

By 1963 the timetable for the Highbridge and Burnham-on-Sea (23) and Cheddar (23A) services drew passengers' attention to the fact that these services were operated as 'pay as you enter' and that passengers should have the correct money ready when they boarded. About this time the company also had to face the consequences of the Beeching Plan for modernising the railways, since at the public inquiries held before the closure of a railway line the company's proposals for replacement bus services were an integral part of the alternatives being offered to passengers who were about to lose their train service.

Passenger numbers had started to decline due to the increase in the availability of private cars and the reduction in the use of the cinema and theatres due to the advent of television. However, in addition to carrying fare-paying passengers, the company regularly advertised the carriage of parcels by country bus, and this produced another important revenue stream, until the threat of terrorism in the 1970s caused its withdrawal.

Timetables for a number of services had become complicated due to the differing number of variations to many routes, such as that for the Weston-super-Mare (24) route, which also showed the 24D via Claverham, the 24B and 24C terminating at Nailsea and the 24E, which followed the 24 as far as Congresbury and then continued to Winscombe! As a result, the first step to reforming this complicated service number pattern was taken in 1966 when, initially, the Hanham local bus network, which had previously been numbered from 300, was renumbered from 380 onwards, with the majority of the Bristol country bus network being renumbered in the 300–399 series.

The company's remaining routes were also renumbered at around the same time, the new pattern being as follows:

1–99, Bristol Joint Services
100 plus, Weston-super-Mare and Wells area services
200 plus, Bath area services
300 plus, Bristol area country services
400 plus, Stroud and Swindon area services
500 plus, Gloucester and Cheltenham area services

1966 saw the opening of the Severn Bridge between Aust and Chepstow, providing a direct link between the West Country and South Wales. The opening of the bridge on 5 September 1966 by Her Majesty the Queen placed a great strain on the resources of the company as not only were a large number of private hire coaches provided for the dignitaries attending the event, but spectators were also taken out to the bridge on a fleet of buses from Marlborough Street. The following day saw the commencement of two new services operated jointly with Red & White Services of Chepstow. Service 300 was an hourly stopping service from Bristol via Filton, Aust, the bridge, Chepstow, the A48, Newport and Cardiff, while service 301 was a two-hourly limited-stop service from Bristol via Westbury on Trym, the bridge, Newport and Cardiff. Initially the 300 service was operated by both companies, using Red & White's recently delivered rear-engined Bristol RELL fifty-four-seat saloons, three of which were hired to the Bristol company for that purpose. The company's 301 service allocation was usually one of the recently delivered six-cylinder Bristol MW dual-purpose vehicles, with both routes operating with conductors from their introduction. The following year the company received its own Bristol RELL buses and, apart from the 300/301 services, the initial Bristol allocation of these vehicles were used with conductors on the services to Chipping Sodbury (318), Frampton Cottrell (326/327), and Thornbury/Cheltenham (329/529). Two years after the introduction of the Severn Bridge services, and in light of operational experience, the stopping service was reduced in frequency and cut back to operate only from Bristol to Chepstow.

In a letter to the staff in a 1969 edition of *Omnibus*, the general manager, Mr E. W. A. Butcher, commented that, 'severe staff shortages and strict observation of the Drivers' Hours Regulations have meant that we have been unable to provide the quality of service which our customers deserve.' For Bristol country services, this was a double blow since Marlborough Street, because of its history, was staffed by crews who wished to transfer from the city depots, as staff recruitment, training and depot allocation was controlled centrally, and in view of the prevailing staff shortages the management at city depots were reluctant to let 'their' staff transfer out. Secondly, as Marlborough Street equally suffered from staff shortages due to this, the duty inspectors could either withdraw a journey (or journeys) on a frequent route (such as the 339 to Bath) from service when no staff were available, or withdraw a very infrequent country service. There really was little choice in this and, because of these

staff shortages, the more frequent country services to Bath, Clevedon and Portishead became unreliable as a result.

Also in 1969, an effort was made to speed up some journey times so as to compete more favourably with the private car: the Bristol–Gloucester–Cheltenham (529) service became limited stop over certain sections, and a new commuter-orientated limited-stop facility was introduced between Weston-super-Mare and Bristol. Further limited-stop services were introduced in the following year, principally to provide Saturday-only shopping facilities to Bristol. In September 1969 the general manager informed staff that a new pay deal had been negotiated with the department of employment and productivity and that, although this would make bus driving a more attractive and lucrative job and thus address staff shortages, 'it would need to be paid for in two ways, in a continued progression of one man operation, now to encompass more of the busy services, and an increase in fares.' By April 1970 it had been declared that 'the recent wage award for the whole company had cost £700,000 and that another fares increase, the second in twelve months, was planned.'

The formation of the National Bus Company in 1969 had resulted in the introduction of a nationwide livery of green and white or red and white (with some companies being painted blue for a few years); the Bristol fleet gradually adopted the new green-and-white colours with a block-capital BRISTOL fleetname, together with the 'double N' National Bus Company logo. Staff were issued with a more modern uniform in a much lighter colour than the previous standard black.

As expected, the unreliability of services caused by the prevailing staff shortages, and the fares increases resulting from the revised bus crews' wage agreements had a knock-on effect in the number of passengers carried as they sought out other means of transport. This resulted in the continuing service cuts that were to be the hallmark of the late 1960s and early 1970s.

In the 1972 Local Government Act powers were given to local authorities to provide financial aid for bus services that ran at a loss, and that would otherwise be withdrawn. The company embarked upon a comprehensive review of all timetabled journeys so as to identify those that failed to cover their costs of operation, and then entered into negotiations with local authorities to seek funding for those services. The consequential introduction of Avon County Council in 1974 (formed from parts of the counties of Gloucestershire, Bristol and Somerset, and intended to encompass the Bristol and Bath journey-to-work area) resulted in a solid negotiating base between the authority and the company so as to provide a network of country service throughout the Avon area, supported by cross subsidy and local authority grant aid.

In June 1972 British Rail had opened a new railway station at the junction of the Bristol–Birmingham and London–South Wales railway lines. Bristol Parkway station was intended to attract commuters from the growing housing estates of north-west Bristol and, although it featured a large car park, both city and country buses were diverted to call at the station. In the case of country services, Hanham local service 380 was extended from Frenchay westwards to the new station and on to Filton church, to the north of the city. In May 1973, as a direct result of the agreement with the staff

representatives to advance the introduction of one-person operation on the busier services, the conductors were removed from the Weston-super-Mare (352/353) and Clevedon (362/363) services, using newly delivered fifty-seat Bristol RELL saloons. The RE-type was quickly becoming the standard single-deck bus for country services.

In February 1974 the frequent service to Portishead (358/359) was converted to single-deck one-person operation, although seventy-seat double-deckers were scheduled in at peak times on the busiest journeys. The continuing need to reduce costs because of falling revenue left virtually no service unaltered and the Bristol country bus timetable for 1978 was followed by no fewer than eight amendments. Most longer-distance services had gradually been truncated at the Avon County Council boundary, usually because the neighbouring authority had not made financial resources available for the continuation of the link with Bristol.

At the end of 1980 further reductions had been made in evening and Sunday services, while, as a result of the cessation of the Bristol Joint Services agreement in 1978, many city services were revised and extended beyond their previous terminal points into the new suburbs that had been built since the signing of the agreement in 1937. Most of these changes affected the east of the city and the Hanham local services, as well as the withdrawal of services 387/388, which had previously connected Bristol bus station with Warmley, Kingswood, Oldland and Bitton. Having lost many of the services it operated, Hanham depot was eventually closed.

By mid-1981 the remnants of the Cirencester service, which had been truncated at Tetbury, was now terminating at Hawksbury Upton; the Chepstow (300) and Pucklechurch (389) had seen further reductions; the circuitous route between Bristol and Gloucester (525/526) was cut back to operate between Bristol and Dursley, via Yate; and some journeys were now operated by a new outstation based in a school yard at Wotton-under-Edge. The services between Bristol, Yate and Chipping Sodbury were revised yet again (the local road layout never did allow for a simple service pattern) and the limited-stop service to Cardiff was renumbered to X10 (from 301).

In early 1981 the Portishead (358/359) services were reduced to run at half-hourly intervals (via alternate routes), and a new limited-stop service (805) was devised to leave Bristol via the Portway to Avonmouth and then over the new motorway bridge to Portishead and on to Clevedon at hourly intervals. Many of these service alterations had come about because of the National Bus Company's use of the Market Analysis Project (MAP), which again saw journeys surveyed and the results analysed so as to provide service patterns that more closely matched supply with demand, and placed a greater emphasis on the use of double-deckers. A small number of single-door double-deck rear-engined Bristol VRs had already been delivered to the country fleet, but, because of this requirement for a larger number of one-person operated Bristol VRs, the company purchased a number of second-hand examples. These included the entire batch of high-bodied vehicles delivered new to London Country Bus Services, with many of these being placed into service in Bristol and Bath still carrying Grays (Essex) area advertisements! The Weston-super-Mare service (352/353) was principally operated by that town's depot (with four vehicles against Bristol's one) and a number

of dual-doorway Bristol VRs, made surplus from Bristol's city services where they were replaced with FLFs, were sent there and often operated on this service. Dual-doorway Bristol VRs also worked at Marlborough Street depot but were not readily accepted by the drivers' representatives, on the basis that many stops in the country had only a small hard-standing by the stop for passengers to board and alight from; the use of a central exit would result in passengers stepping from the bus on to grass or mud.

Because of the cessation of production of the Bristol RE saloon, new buses for country services from the mid-1970s were the new National Bus Company's standard, the Leyland National, augmented by Bristol's new lightweight single-decker, the Bristol LH. Because of the general shortage of double-deck vehicles the Bristol–Wells–Glastonbury Street (376) service, which was operated by the small Wells (Somerset) depot, had been converted to operate with recently delivered Leyland National 2 single-deckers with the depot staff representatives agreeing to carry up to twenty-two standing passengers.

By the summer of 1982 the Yate and Chipping Sodbury services had been revised yet again and an hourly limited-stop service introduced, coming into Bristol via the urban M32 motorway, and advertised as 'the X8, ex-Yate'! Meanwhile the Cardiff express service had been extended westwards beyond Cardiff, and even Swansea, to Haverfordwest! The Bristol company retained one vehicle working on what was now a complicated hourly service, operated in addition by National Welsh and South Wales Transport and marketed under the name 'Expresswest'.

The National Bus Company had previously announced that, along with a number of larger group companies, the Bristol company would be broken up; in September 1983 the company was split into four separate units, with Bristol's country bus depot at Marlborough Street, Bath and Weston-super-Mare forming a new separately managed division within the Bristol Omnibus Co. under a new manager, Trevor Smallwood. Each of the three areas now operated as profit centres under district managers, eventually with new local fleetnames. Bristol's Marlborough Street operation operated under the new fleet name of 'BRISTOL – COUNTRY BUS'.

In mid-1983 a new limited-stop service was formed by the linking of some services between Bristol and Bath, Bath and Warminster, and Westbury and Salisbury, resulting in the X41 service. This operated at hourly intervals between Bristol and Warminster, continuing every two hours to Salisbury and providing new local bus links from Bristol, jointly operated with Salisbury-based Wilts & Dorset. A number of recently delivered Leyland National 2 buses were fitted with dual-purpose seats and repainted into a brighter livery for this X41 service. Similarly, in a continuing effort to make bus travel more attractive, a number of double-deckers, including recently delivered Leyland Olympian buses, were fitted with high-backed, more comfortable seats. By now there were up to twelve limited-stop services running into Bristol's bus station, carrying route numbers in the 800 series: the 'Expresswest' group of routes were now numbered 610/611/612 as part of the National Express Network.

More limited stop journeys were provided between Weston-super-Mare and Bristol (eventually becoming an hourly service, with additional buses at peak periods) and, in the summer of 1984, Marlborough Street depot introduced a variety of

'Double Deck Special' routes during the school holidays and on summer weekends. These provided day trips and weekend period returns between Bristol and various seaside resorts on the south and west coasts of Somerset, Dorset and Devon, using dual-purpose seated Leyland Olympian double-deckers. The period-return services were augmented by single-deck coaches and dual-purpose vehicles.

The 1984 'Buses' white paper resulted in the 1985 Transport Act, which declared that bus services in Britain (outside of London) would be deregulated, requiring a qualified operator only to register a service with the Traffic Commissioner if that company thought that the service could be operated commercially. It also gave local authorities the powers to tender for the provision of those services that were considered by operators to be uneconomical, but which were considered to be socially necessary by the local authority. This new regime was to be implemented from 26 October 1986 ('D-Day'). The Act also legislated for the National Bus Company to be broken up and constituent companies sold into the private sector.

In the lead up to D-Day, the company identified the network it would operate commercially, this network having to be registered by 26 January 1986. From April 1985 the two remaining sections of the Bristol Omnibus Company were re-branded so as to make them more easily identifiable under the upcoming competitive environment with a view to creating brand loyalty: the part of the company operating the country services was marketed under the new name 'Badgerline'. Over a period of time a new, brighter livery of green and yellow was introduced, together with suitably placed reflective vinyls repeating the friendly Badger logo. In that year, and in preparation for protecting the company's customer base after deregulation, a number of local minibus schemes were introduced throughout the operating area, principally using sixteen-seat Ford Transit buses.

On 1 January 1986, Badgerline became a separate limited company and, later in the year, the local authorities (which in the case of Bristol country services was principally Avon County Council) issued tender documents for those services (or links) that had not been registered but that were considered by those authorities as socially necessary. In due course, Badgerline was successful in winning a number of those tenders, including for some services operating wholly within the city of Bristol.

On 23 September of that year, the Badgerline company was sold by the National Bus Company to its management and staff and, finally, on 26 October the newly privatised company began operating Bristol country bus services under the new, deregulated regime.

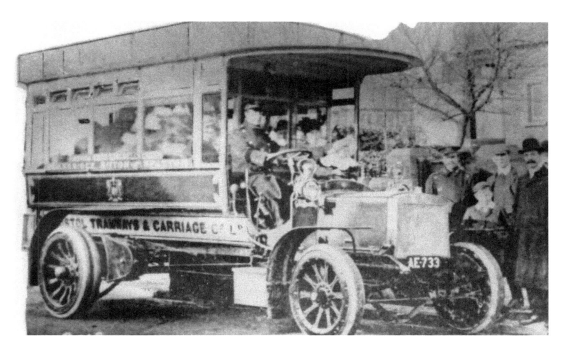

The introduction of motor buses allowed the Bristol Tramways Co. to operate services beyond the tram terminals into the country. AE733 was a 1906 Thornycroft, shown operating east from the Hanham tram terminus to Kelston. (*BVBG*)

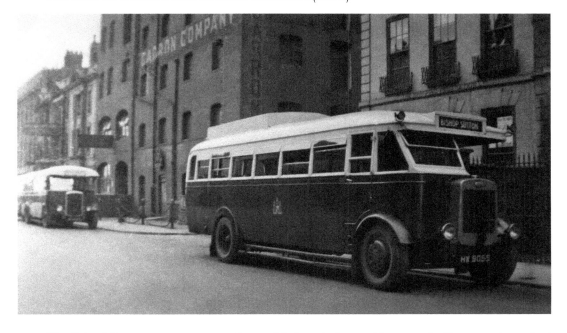

The Bristol B-type was a great step forward in bus design and became the Tramways' standard single-deck bus for the 1930s. HW9055 was new to Greyhound Motors as a coach but its Northern Counties body was not altered when it was relegated to bus duties. It is shown ready for a journey to Bishop Sutton in the Chew valley, south of Bristol. (*BVBG*)

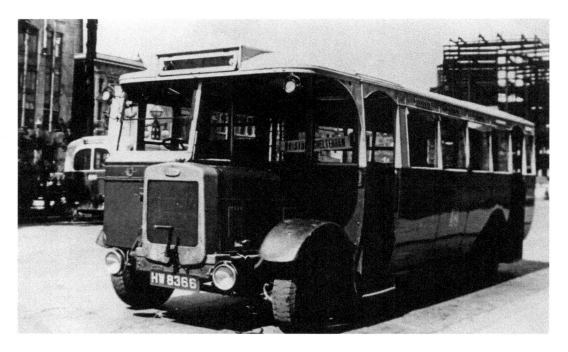

Two-doorway Bristol-bodied 1930 Bristol B HW8366 was numbered B378 when new before, seven years later, being renumbered 371. The route from Bristol north to Cheltenham, via Thornbury, Berkeley and Gloucester, was one of the longest country routes at the time. (*BVBG*)

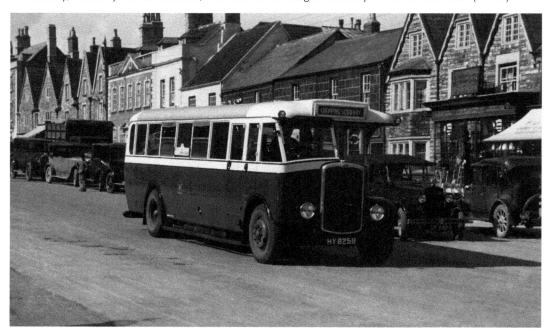

The successor to the B-type was the J-type. HY8259 received fleet number J120 and was built in 1933 with Bristol's own thirty-four-seat dual-doorway bodywork, and was photographed operating the Chipping Sodbury service to the north-east of the city. (*BVBG*)

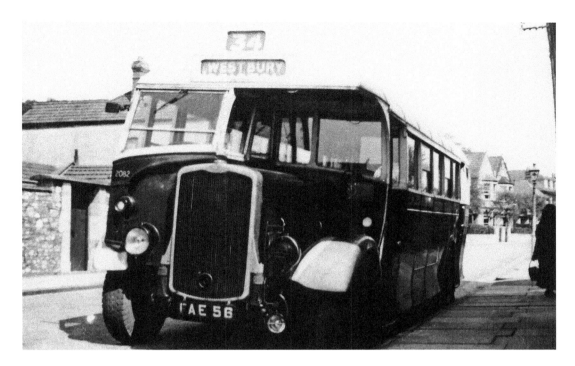

FAE56 was the first Bristol L-type saloon, new in 1938 with Bristol's own dual-doorway thirty-two-seat body and fitted from new with a Gardner diesel engine. The 34 service operated from the Westbury-on-Trym tram terminus to Severn Beach, on the banks of the River Severn. (*Geoff Lusher collection*)

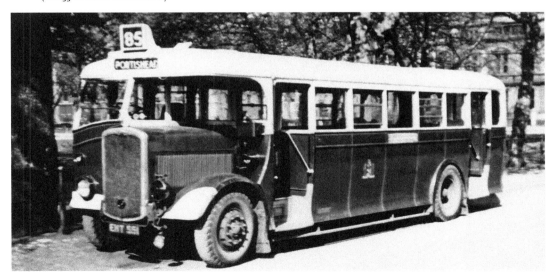

EHT551 from 1937 was a Bristol J05G with Bristol's own dual-door thirty-four-seat body and is pictured with wartime white wings while laying over in Queen Square, central Bristol, ready for the 85 service to Portishead, at the mouth of the River Avon. To reach Portishead the driver would have to tackle the notorious Rownham Hill, with a maximum gradient of 1 in 5 and an average of 1 in 10. (*Geoff Lusher collection*)

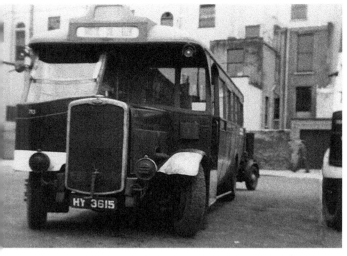

Bristol-bodied HY3615 was a 1931 Bristol D-type, which was renumbered from D126 to 713 in 1937 and from October 1939 towed a producer gas trailer – in this case between Bristol and Cheltenham. (*Omnibus Society*)

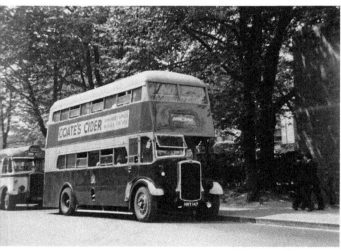

Double-deckers were gradually introduced on to country services during the 1930s: 3626, HHT147, was a 1942 Bristol K5G with the company's own bodywork. It is shown at the Centre in wartime guise, dressed for a journey to Chipping Sodbury. The coach behind carries the Bristol Greyhound insignia and livery, but would have been used as a bus during the war. (*Omnibus Society*)

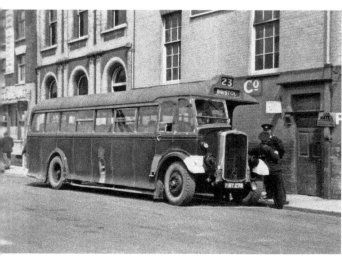

The longest country route south from Bristol was the 23 along the A38 to Bridgwater via Churchill Gate and Highbridge. FHT278, fleet number 2131, a 1939 Bristol L5G, is shown in wartime grey and blue livery. (*Omnibus Society*)

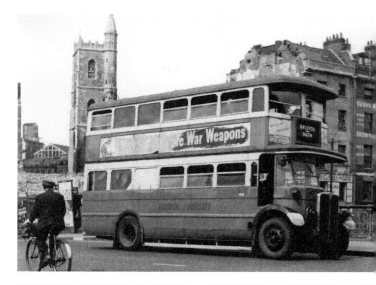

In addition to buying second-hand buses during the war years, the company also hired vehicles from other operators. 3705, GK5481, a London General-bodied AEC Regent ST, came from the London Passenger Transport Board in 1942 and returned thence in 1946. It was photographed operating on the Bristol–Bath 33 service. (*Geoff Lusher collection*)

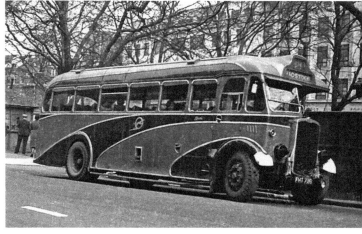

1939 Bristol L5G Greyhound coach FHT786, 2149, in wartime blue and grey livery is pictured operating between Bristol and Radstock, providing a level of luxury in its Duple body that belied the austerity conditions of the time. (*BVBG*)

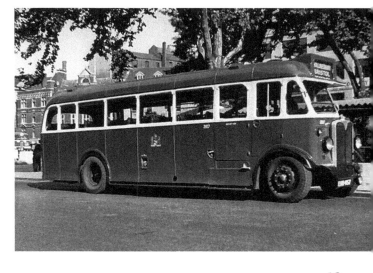

2107, EHW437, a 1938 AEC Regal 0662, operating between Bristol and Malmesbury (to the north-east of the city), was new as a thirty-two-seat coach. (*BVBG*)

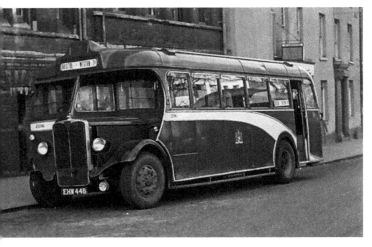

2096, EHW446, a Duple-bodied AEC Regal coach, spent some of the war years with the Royal Navy, but is shown here in peaceful times operating between Bristol and Weston-super-Mare, the popular seaside resort on the Somerset coast. (*BVBG*)

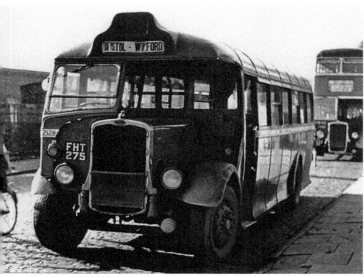

1939 Bristol-bodied Bristol L5G 2128, FHT275, was converted to perimeter seating during the war years (thus allowing a greater area for standing passengers) and received a 'V' (for victory) prefix to its fleet number. Winford, to the south of Bristol, was an important local orthopaedic hospital, and justified the operation of additional journeys to the regular schedule. By 1950 this bus had joined the Gloucester city bus fleet. (*BVBG*)

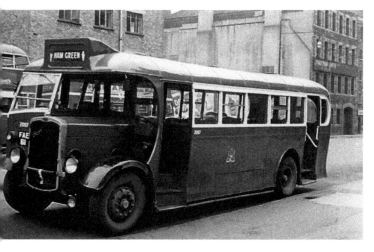

Ham Green was an important isolation and TB hospital, close to Portishead. FAE61, 2087, was a 1938 Bristol L5G with a thirty-two-seat Bristol-built body boasting twin doors, which was quite usual for Bristol saloons of the era. (*BVBG*)

BHU650 was new in 1935 as J173, a Bristol J-type with Bristol's own coach body, and became 2055 in 1937 when it was fitted with a Gardner diesel engine. In 1941 it was fitted with this Bristol-designed, Bence-built thirty-seven-seat rear entrance body to Ministry of Supply specification and lasted until 1955. The bus is set for a journey to Chew Magna, in the Chew Valley to the south of the city and in Somerset. (*M. Mogridge*)

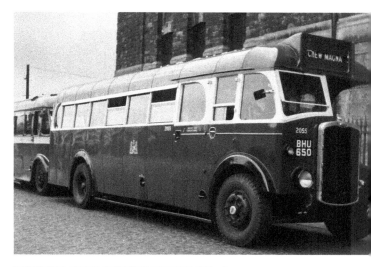

FHT818, a twenty-seat Duple semi-coach-bodied Bedford WTB, was new in 1939 as 2158, although it was soon renumbered 201. Its small size was useful for the narrow country lanes between Thornbury and Tytherington in south Gloucestershire, but it was withdrawn in 1950. (*BVBG*)

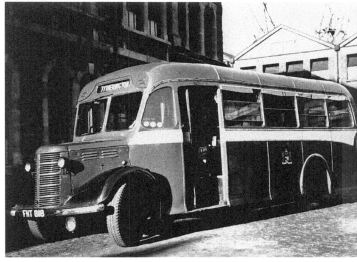

Looking brand new, 4100, KHU621, entered service in August of 1947, soon receiving the 'L' fleet number prefix that would identify it as having a lowbridge ECW body. It was delivered new with an AEC six-cylinder engine. The post-war shortage of destination linen resulted in this lazy blind for the Bristol–Thornbury service, normally a highbridge route. (*Peter Davey*)

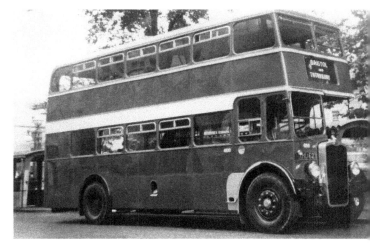

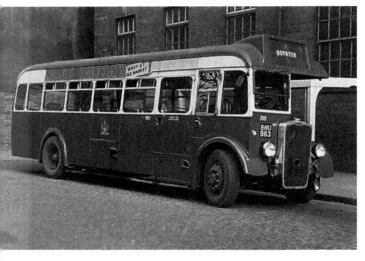

BHU963, a 1935 Bristol JNW, had been new as fleet number N54; it was renumbered 598 and then 2115 when fitted with a diesel engine. In 1948 it received a new Bristol thirty-five-seat body, and then a modified front end and the lower PV2 radiator shown here. Doynton was close to Marshfield and Chippenham. (*BVBG*)

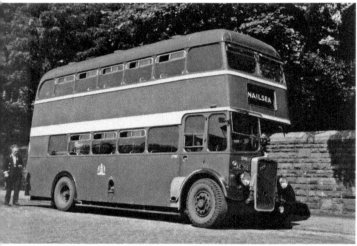

New vehicle deliveries became more frequent after the cessation of hostilities and 3745, LAE318, was one of over 175 buses new in 1948. A fifty-six-seat ECW highbridge Bristol K6B, it is shown operating between Bristol and Nailsea. It would have operated via Wraxall, as the route via Backwell encountered a single-deck-only low railway bridge. (*BVBG*)

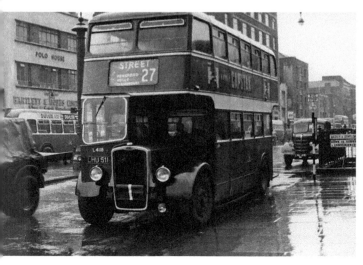

The 27 service to Wells, Glastonbury and Street required low-height buses because of a number of low railway bridges on the route. L4118, LHU511, was a Bristol AVW-engined ECW-bodied Bristol K, dating from 1948. It is shown in a wet Prince Street, Bristol. (*Geoff Lusher collection*)

Service 302 was one of the orbital Hanham local services operated by Hanham depot. AHU807 was a 1934 Bristol J-type coach, formerly J138 but latterly 753. Its body was destroyed by enemy action and a second-hand Duple coach body was fitted. As 2359, in 1951, it received a modified front end and this new Bristol-built bus body, believed to have been assembled from ECW parts. (*BVBG*)

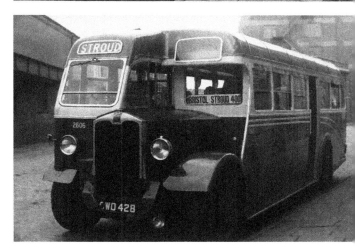

The Red & White services operation at Stroud, Gloucestershire, was acquired by Tramways in May 1950 in exchange for the Tramways' operation in the Forest of Dean. Red & White GWO428 briefly became Tramways 2606 but, by the January of the following year, it had been returned. Unusually for the Tramways' fleet, it was a 1939 Albion-engined CX13 with central entrance Duple bodywork. It was photographed in central Bristol, operating the newly introduced service from Stroud. (*BVBG*)

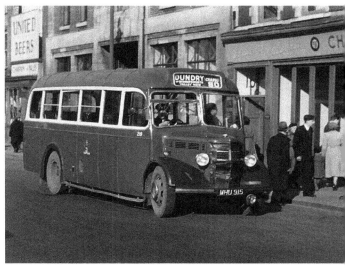

New in 1950, 219, MHU915, was a Mulliner-bodied petrol-engined Bedford OB bus that had been ordered by Ball, Dundry Pioneer, but delivered new to Tramways. In keeping with its roots, the bus is operating between Bristol and Dundry. (*BVBG*)

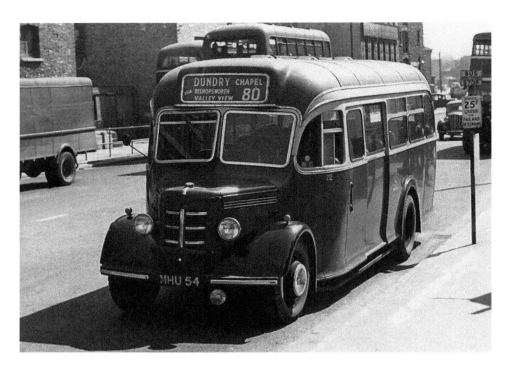

Bus-bodied petrol-engined Bedford OBs, ordered by Tramways but with Duple bus bodies, were also new in 1950. Thirty-seat 212, MHU54, is also shown operating to Dundry, which was a twisting route much suited to the smaller bus. (*BVBG*)

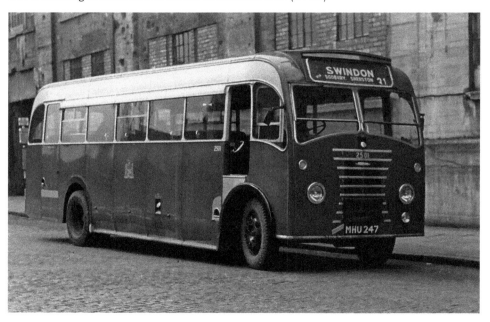

Two unusual Saurer diesel-engined Beadle-Morris integral buses were new in 1949, lasting nine years in service. 2501, MHU247, is dressed for a journey from Bristol to Swindon – a journey of some 40 plus miles! (*BVBG*)

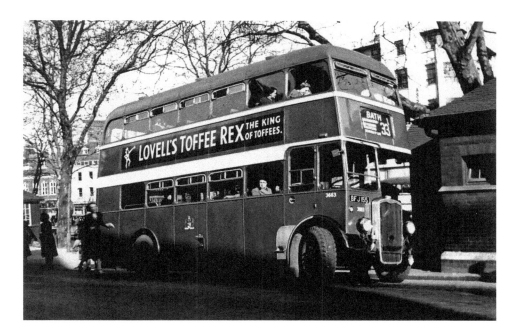

3663, BFJ155, was acquired from Exeter Corporation in 1945. In late 1948 the original Bristol-built body on this 1935 Bristol G05G was replaced with this newly built Tilling standard fifty-six-seat ECW one. Sometime between then and 1951, when the bus was transferred to Gloucester city services, it is shown at the Tramway Centre operating service 33, the frequent trunk route to Bath. (*BVBG*)

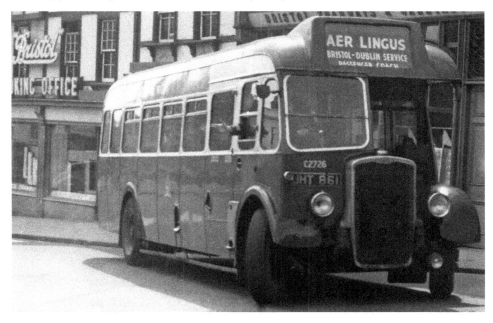

1947 ECW thirty-three-seat dual-doorway Bristol L5G C2726, JHT861, of the BJS fleet, is pictured leaving the company's Tramways Centre offices for a journey to Bristol airport for Aer Lingus passengers. (*BVBG*)

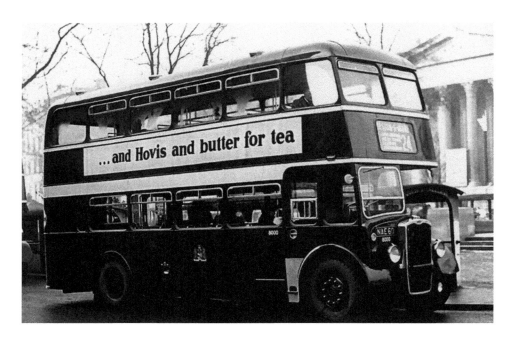

In 1950 a revised double-deck chassis was introduced, the Bristol KSW, which supported 8-foot-wide ECW bodywork, as indicated by the white steering wheel shown here on the nominal prototype 8000, NAE60. The bus is shown at the Tramways Centre, ready for a journey to Weston-super-Mare on service 24. Despite operating on a 24-mile country service the bus had an open back platform and no passenger heaters. (*BVBG*)

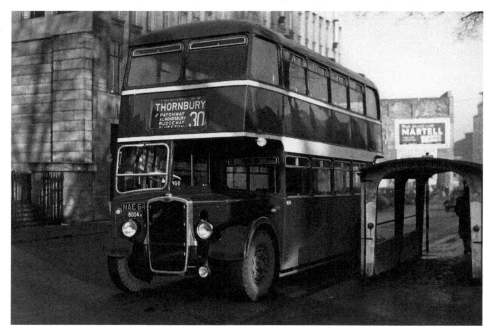

Similar bus 8004, NAE64, waits in central Bristol for a journey to Thornbury, north of the city. (*BVBG*)

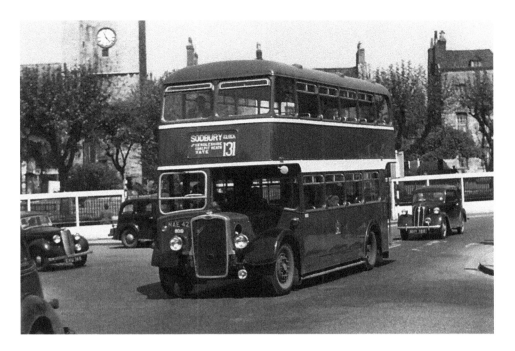

A small number of the 1951 double-deck deliveries were of the narrower Bristol KS chassis, which were 7 feet 6 inches wide, although fitted with 8-foot-wide ECW bodies. The body overhang can be clearly seen as a gap between the edge of the front and rear wings and the tyres in this view of 8010, NAE42, operating to Chipping Sodbury. (*BVBG*)

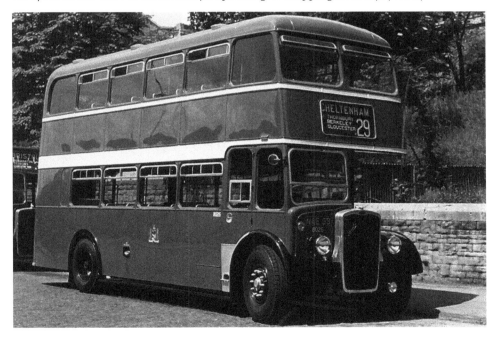

8026, NAE58, also from 1951 and looking brand new, is a similar KSW operating the long trunk route to Thornbury, Berkeley, Gloucester and Cheltenham. (*BVBG*)

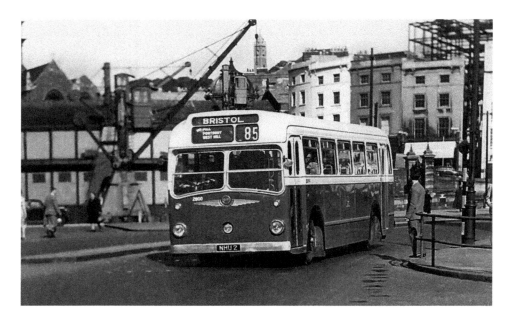

Another major development for the fleet in 1951 was the first underfloor-engined Bristol saloon, Bristol LSX NHU2, numbered 2800. Initially it was fitted with an experimental horizontal Bristol engine, narrow axles and two doors in its ECW body. The bus is shown crossing the Tramways Centre into Prince Street, coming from Portishead. (*BVBG*)

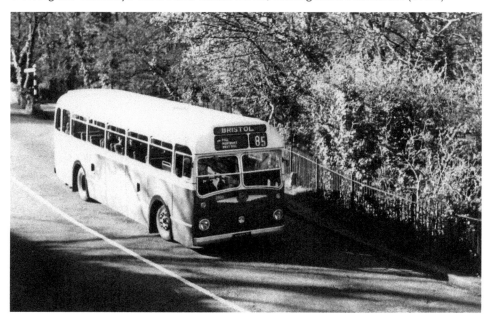

The Portishead route was renowned for the steep Rownham Hill, which was as much a problem for buses ascending towards Portishead as for those descending towards Bristol. The bus stop at the top of the hill demanded that drivers stop there and engage second gear before descending: the driver of prototype Bristol LSX 2800 has just done that. (*Geoff Lusher collection*)

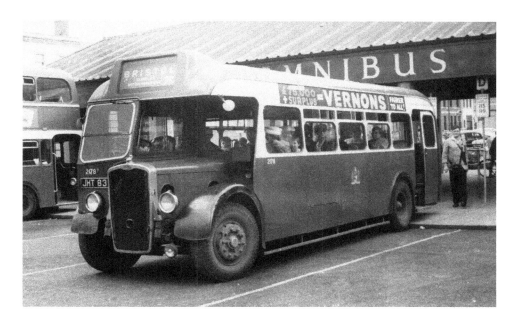

1946 ECW-bodied thirty-five-seat Bristol L5G 2178, JHT831, represents the early version of the Tilling standard bodywork: later models would have the sliding windows incorporated into the rubber mountings. The conductor is about to board the bus at Gloucester bus station for a long journey to Bristol, going the 'pretty way' through Dursley and Wotton-under-Edge on service 26. (*BVBG*)

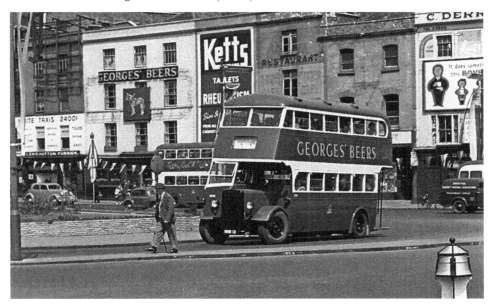

During the war, the Ministry of Supply authorised Guy Motors to build double-deck bus chassis; these were allocated by the Ministry, and the company received twelve of them. 3638, HHW13, new in 1943, which received a second-hand body in 1951, heels over whilst rounding the Tramways Centre returning to its home town of Western-super-Mare with a full load. (*BVBG*)

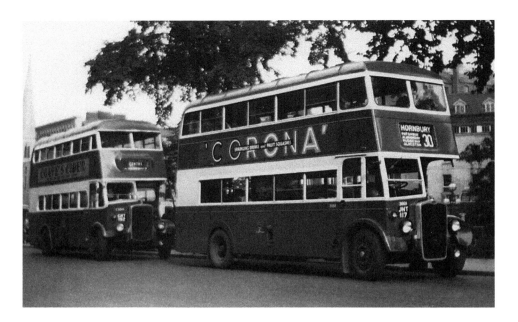

The Duple fifty-six-seat body on 1946 Bristol K6A 3668, JHT117, was built to relaxed Ministry of Supply specifications and was later painted into this brighter 'Festival of Britain' livery. Standing at the Tramways Centre and ready for a journey north to Thornbury, the bus shares the stop with an earlier BJS bus. (*BVBG*)

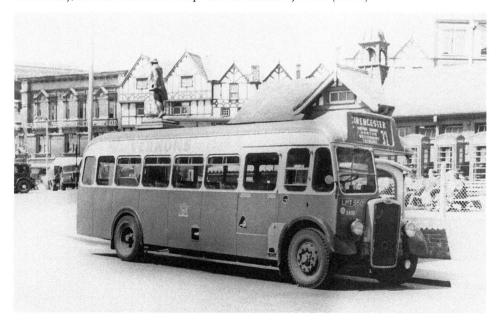

Until delivery of underfloor-engined buses in the mid-1950s the thirty-five-seat rear-entrance Bristol L-type was the standard bus for Bristol's country services. 1949-built 2430, LHY950, stands at the Tramways Centre awaiting a departure for Cirencester, north-east of the city in Gloucestershire. Behind is the mock-Tudor frontage of the company's head office. (*BVBG*)

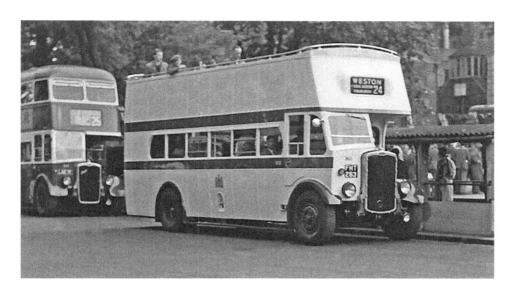

FHT263 was new in 1939 as BJS bus C3219, one of a large number of Bristol-bodied tram-replacement Bristol K5Gs. In 1951 it was rebuilt as an open top bus for the seafront service at Weston-super-Mare and renumbered 3613 in the country fleet. Standing at the Tramways Centre in Bristol, the bus has been pressed into service on the 24 route to its home town and, looking particularly shiny, may well have been on its delivery run from Central Works. (*BVBG*)

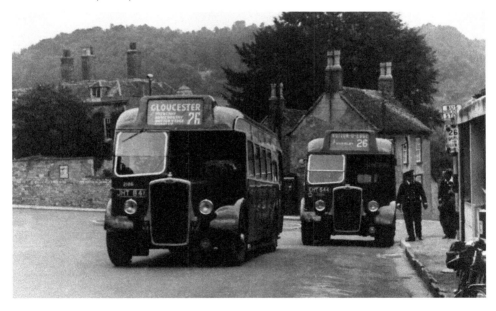

2186, JHT841, was new in 1947 as a Bristol L6A but was later re-engined with a Gardner five-cylinder unit. Pictured in late 1952, it stands alongside 2058, EHT544, a 1937 Bristol JO5G rebodied by the company's own body-building works in 1950 and fitted with the newer, lower, front end. They are pictured in Wotton-under-Edge, Gloucestershire; 2186 seems to be on the through service from Bristol to Gloucester, while 2058 has terminated here. (*Geoff Lusher collection*)

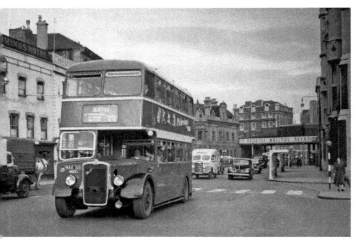

Passing the bottom of the incline to Bristol Temple Meads station while en route to Bath on frequent service 33 is 1951 ECW-bodied Bristol KSW6B 8027, NAE59. (*BVBG*)

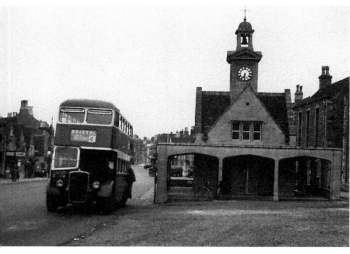

1948 ECW-bodied fifty-six-seat Bristol K6B 3762, LHU971, is inbound to Bristol in Chipping Sodbury High Street in the early 1950s. (*Phil Sposito*)

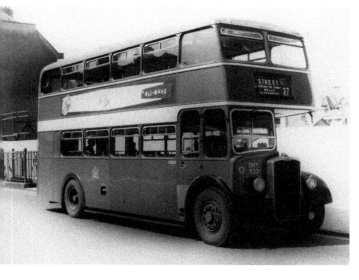

The Bristol company only had ten lowbridge Bristol KSWs, all being new in 1952. L8094, OHY933, is shown in central Bristol, ready for a journey south to Wells, Glastonbury and Street. The destination screen had been masked down to the new company standard. (*BVBG*)

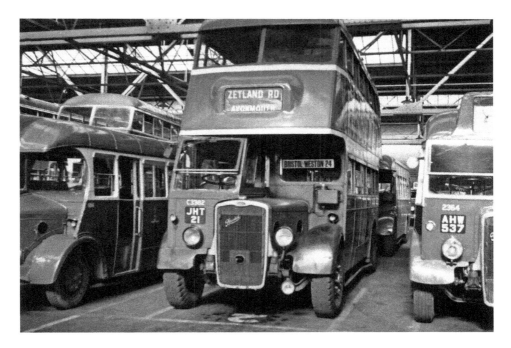

Bristol City buses were used on country services when necessary, and 1946 Bristol K6A C3382, JHT21, is seen here in Weston-super-Mare depot having worked from Bristol, probably as a duplicate journey to cater for holiday and day trip crowds. The bus itself is interesting, having had its Strachan body replaced in 1949 with a 1939 Bristol-built body from fellow K-type C3241. (*Omnibus Society*)

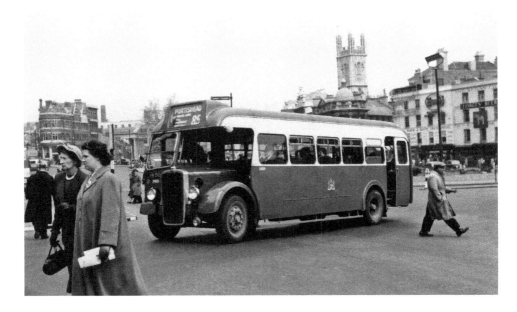

The January weather has influenced the dress of the passers-by as 1949-built ECW-bodied thirty-five-seat Bristol L6B LHW915, 2409, crosses St Augustines Parade to begin its journey to Portishead in this 1954 view. (*Geoff Lusher collection*)

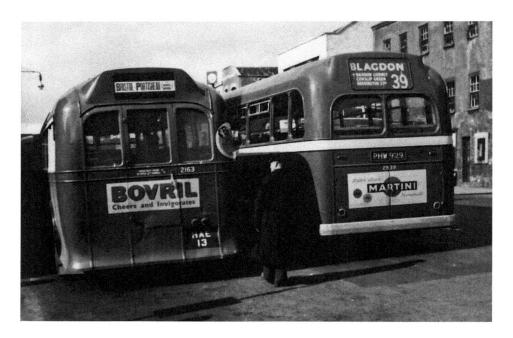

When this photograph was taken in July 1954 ECW-bodied forty-five-seat underfloor-engined Bristol LS5G 2839, PHW929, was but two months old; one year later, 2163, HAE13, a Bristol L5G from 1941, was to receive a second-hand 1949-built body. As a result it continued in service until 1961. (*Geoff Lusher collection*)

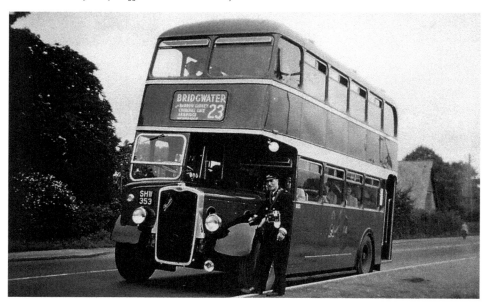

At the beginning of May 1954 the Bridgwater (23) service was converted to double-deck operation. The crew stand alongside brand-new ECW-bodied sixty-seat Bristol KSW6G 8183, SHW353, at Churchill Gate on the A38 south of Bristol; the conductor sports a 'Setright' ticket machine. The rear platform doors are clearly visible. (*Geoff Lusher collection*)

On 2 January 1955 the Portishead (85) service was converted to double-deck operation using a batch of ECW-bodied sixty-seat Bristol KSW6Gs with special gearboxes for dealing with the steep Rownham Hill. 8187, SHW357, was the first of the batch and is photographed in Prince Street, Bristol. Behind the KSW is the prototype Bristol LSX, NHU2, previously shown operating the Portishead route; it has been repainted into normal livery. (*Geoff Lusher collection*)

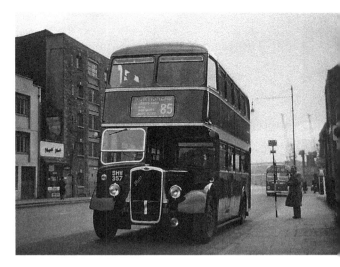

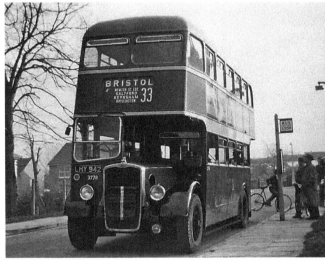

The January 1955 revisions saw the introduction of a local service to Keynsham (33A), which, unlike the Bristol–Bath (33) route, penetrated the housing estates. The honour of being the first bus around Park Estate fell to 1950 ECW-bodied fifty-nine-seat Bristol K6B 3776, LHY942. (*Geoff Lusher collection*)

1942 Bristol L5G 2168, HHT151, was constructed from spare parts before the bus building plant was turned over to war work. In 1955 it was fitted with a modified front end and a second-hand 1949 thirty-five-seat ECW body. The conductor has left the back of his bus to talk to his driver in this view taken at the Dundry terminus of service 80. (*Geoff Lusher collection*)

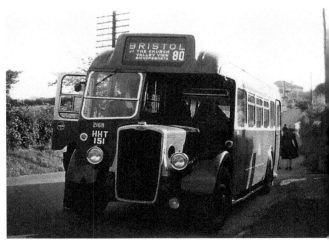

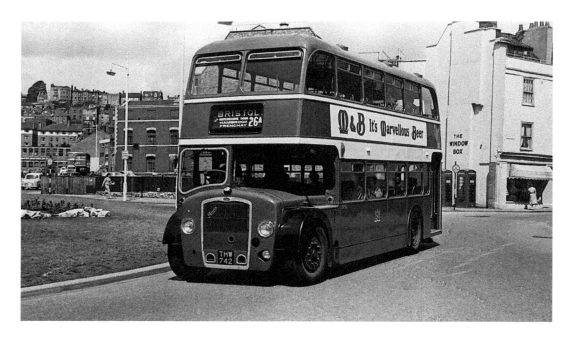

The first production Bristol Lodekka buses for country services were new in 1955 and had conductor-operated platform doors, as shown by this view of ECW-bodied L8252, THW742, rounding St James Barton roundabout in central Bristol. The 26A served Frampton Cotterell. (*Geoff Lusher collection*)

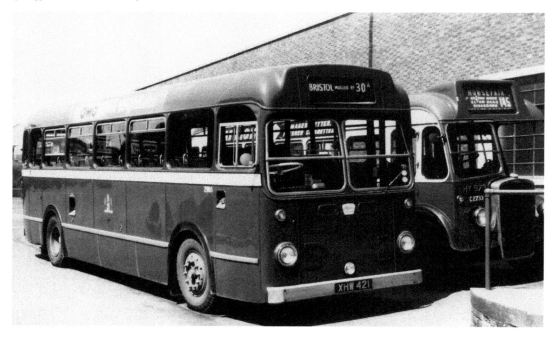

Forty-five-seat ECW-bodied Bristol LS5G saloon 2905, XHW421, is shown at Muller Road depot having worked there from Pilning, close to the River Severn in Gloucestershire, before the opening of Marlborough Street bus station and depot. (*Geoff Lusher collection*)

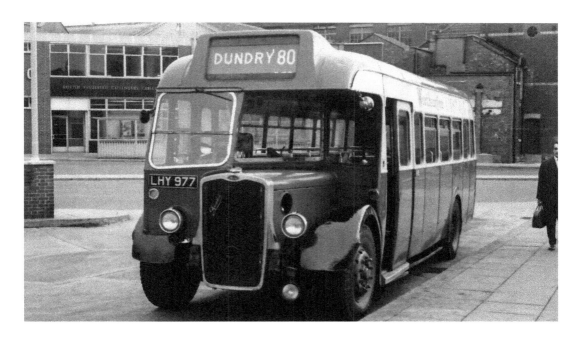

To meet the need for buses capable of operating without a conductor, BJS two-doorway bus C2737, LHY977, a 1949 ECW-bodied Bristol L6B, was transferred to the country fleet, had the rear door removed, and was renumbered as 2479. Note the slanting window above the bonnet, which allowed the driver to turn around to collect the fares as passengers boarded. The bus stands at the entrance to the recently opened central bus and coach station. (*Phil Sposito*)

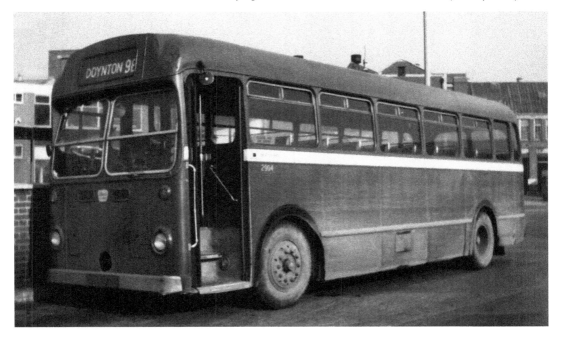

One-person-operated 1957 Bristol LS5G 2904, XHW420, stands near the fuelling bay at Marlborough Street's bus station and depot, dressed for the service to Doynton via Wick, east of Bristol. (*BVBG*)

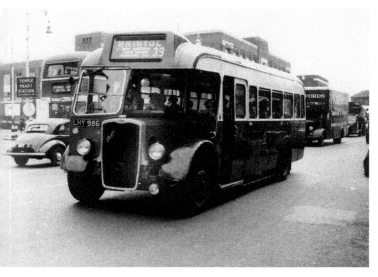

Passing Temple Meads station and heading into central Bristol is former BJS 1950 Bristol L5G LHY986. Its thirty-three-seat dual-doorway ECW body was converted to single-door to enable operation without a conductor when it joined the country fleet; it was renumbered 2485. (*Geoff Lusher collection*)

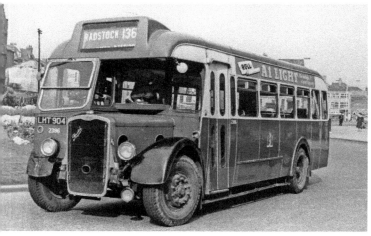

2386, LHT904, was new in 1949 as a thirty-one-seat dual-purpose Bristol L6B: it later received a Gardner engine and, in 1959, a second-hand ECW thirty-five-seat bus body, which was rebuilt for one-person operation, but with a folding door rather than a sliding one. (*BVBG*)

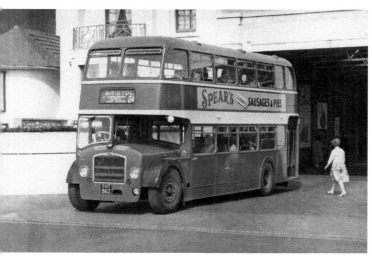

Six experimental 30-foot-long ECW-bodied Bristol Lodekka LDL buses, seating seventy passengers, were produced in 1957, one of which, YHT962, entered service in the country fleet as L8450. By 1963 the bus had been moved to the Bath Tramway fleet but, before that, it is shown leaving Weston-super-Mare's seafront bus station, bound for Bristol. (*Geoff Lusher*)

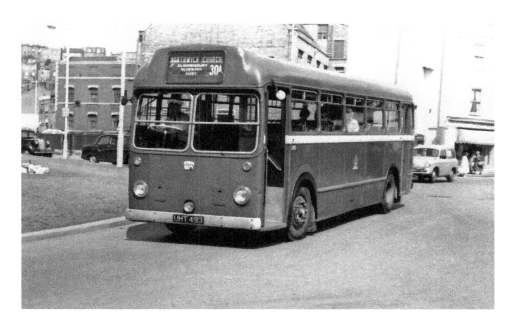

In 1955 the company acquired two Bristol LS development vehicles. One, 2883, UHT493, came from Bristol Commercial Vehicles and was actually new with a Commer TS3 engine, but received a Gardner unit in 1955. Unusually, the bus retained its second, rear door in its forty-three-seat ECW body until 1962. The driver looks resplendent in his summer uniform and cap. (*Phil Sposito*)

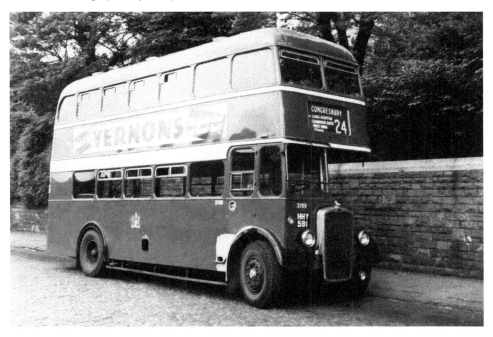

Bristol K6A 3789, HHY591, was new in 1945 as lowbridge bus 3647 (later L3647), being rebuilt and fitted with this ECW highbridge body in 1955. Congresbury is on the A370 between Bristol and Weston-super-Mare. (*Geoff Lusher collection*)

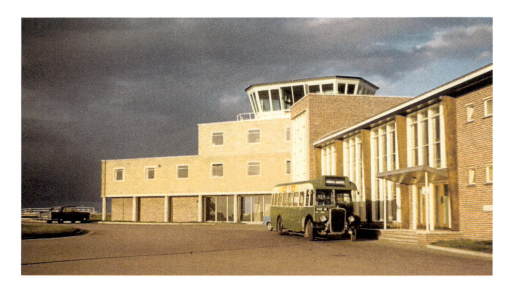

Not a day to be flying! 2165, HAE15, stands outside of the Bristol (Lulsgate) Airport terminal building in August 1962 while providing the Cambrian Airways link to and from the city. This Bristol L5G was new in 1941 with Bristol's own bodywork, this being replaced by a Tilling standard thirty-five-seat rear-entrance body in 1955. The bus was withdrawn from service later in 1962. (*Geoff Gould*)

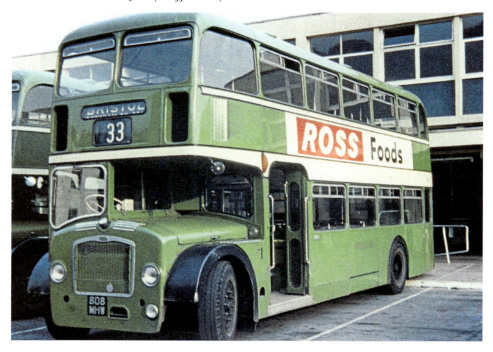

The first of the new seventy-seat ECW-bodied Bristol FLF Lodekka buses for country services were new in 1961. 7013, 808MHW, a Bristol-engined bus, loads at the bus station in Bath for the trunk service to Bristol. Note that the bus station platform is still arranged for rear-loading buses. (*BVBG*)

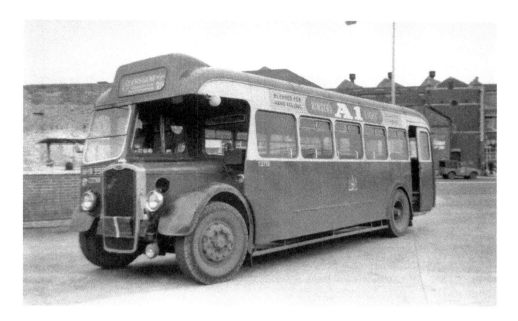

Bristol L6B C2758, MHW998, had actually been a country bus when delivered new in 1950 as 2463, joining the BJS operation in 1959 but retaining the rear entrance in its ECW body. It was the second bus from that year to carry that fleet number, as the previous C2758 had moved the other way in 1953. It is shown in October 1963 outside of the bus and coach station. (*Mike Walker*)

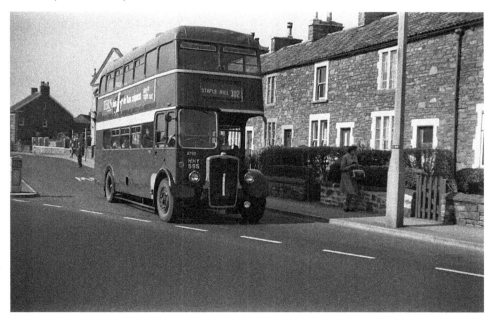

302 was one of the Hanham depot-operated local routes that connected suburbs around the periphery of the city. 3793, HHY595, new as 3641 (later L3641), was one of the 1945 lowbridge Bristol K6As that were rebodied with highbridge ECW bodywork in the mid-1950s. (*Deryck Ball*)

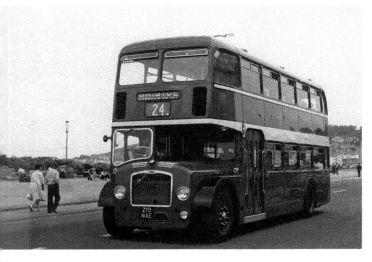

1962 Bristol Lodekka FLF6G 7051, 219NAE, with ECW seventy-seat bodywork, comes to the end of its journey from Bristol along Weston-super-Mare's seafront as it prepares to turn left into the combined bus station and depot. (*Phil Sposito*)

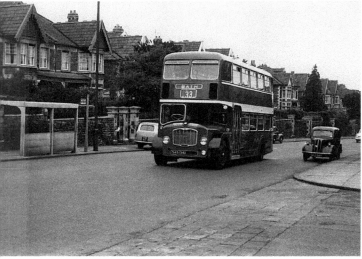

Along with others of the batch 1963 Bristol Lodekka FLF6B, 7100, 545OHU, sported cream window rubbers on its ECW seventy-seat body. The bus is shown climbing the hill from Brislington bus depot on its way to Bath on service 33, passing the entrance to Bristol Commercial Vehicles, where it, and all of its cousins, had been built. (*Phil Sposito*)

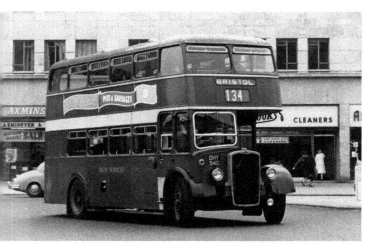

1952-built ECW-bodied lowbridge fifty-five-seat Bristol KSW6G L8095, OHY940, was allocated to the Bath Tramways Motor Co. subsidiary, and is shown operating on the hourly 'back road' service from Bath to Bristol via Kelston, Longwell Green (home of the bus and lorry body building works of the same name) and Hanham. (*S. J. Butler*)

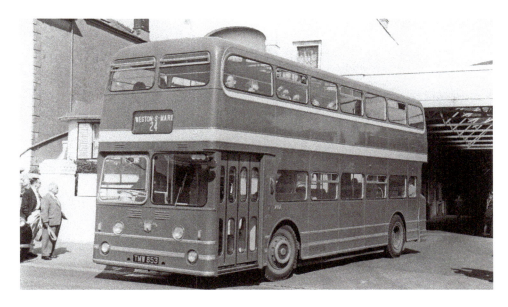

In 1963 the company acquired three rear-engined Weymann-bodied seventy-three-seat lowbridge Leyland Atlantean PDR1/1 buses from neighbouring Wilts & Dorset, who had acquired them with the local Silver Star company. This was because impending railway branch-line closures due to the Beeching Plan were expected to leave the company with capacity problems. Initially allocated to Weston-super-Mare depot, 7997, TMW853, new in 1959, is shown leaving the seafront depot and bus station, bound for Bristol. (*BVBG*)

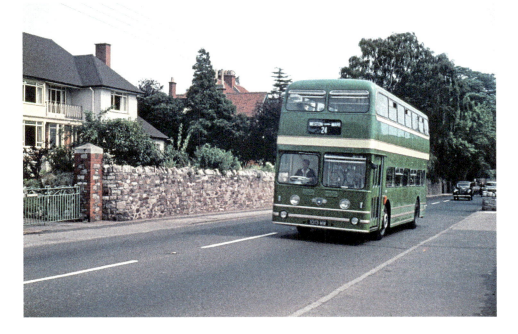

The third Leyland Atlantean (going by numbers), 7999, 1013MW, was new in 1962; it is photographed here operating through Long Ashton, bound for the seaside, in August of 1963. (*Geoff Gould*)

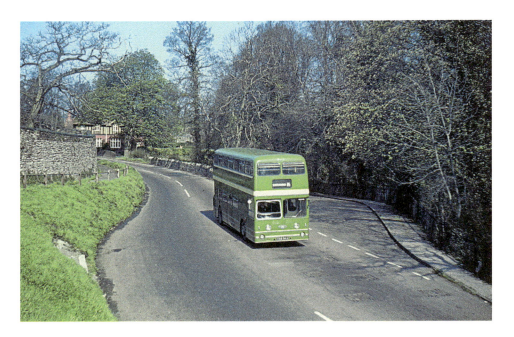

The Leyland Atlanteans were soon moved to Bristol's Marlborough Street depot to provide additional capacity on the Portishead (85) route, due to the closure of the railway branch line from Bristol. New in 1960, 7998, VAM944, was tackling the steep descent of Rownham Hill in 1964, heading for Bristol. These three buses were withdrawn from service the following year. (*Geoff Gould*)

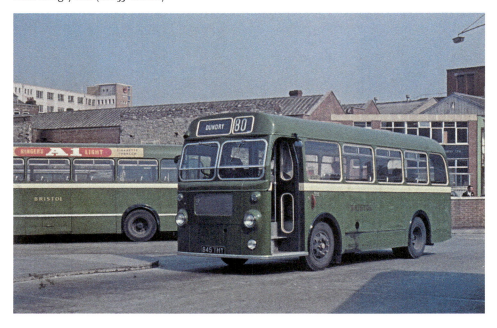

The Dundry service had a history of using small vehicles, and 1963 delivered thirty-seat ECW-bodied Bristol SUS4A 305, 845THY, is no exception. This little bus is shown entering the bus and coach station in central Bristol. (*Geoff Gould*)

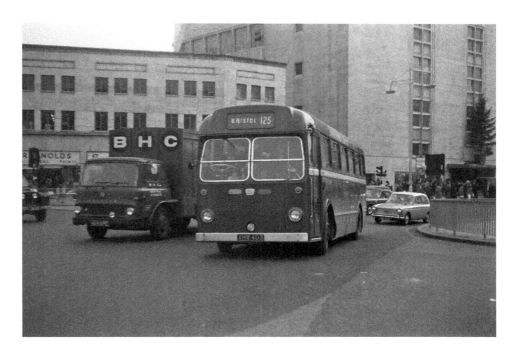

By the time of its delivery in 1956 the ECW-bodied forty-five-seat Bristol LS5G had become the standard single-deck bus for country services. 2887, XHW403, approaches Bristol's bus and coach station from north Somerset in November 1965. (*Mike Walker*)

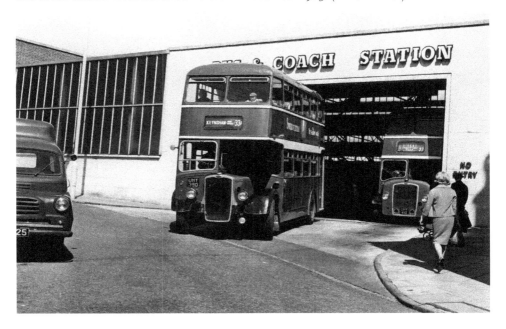

Despite receiving low-height Lodekka buses, Bristol country services still had a need for ECW-bodied sixty-seat highbridge Bristol KSWs, as shown by 8342, UHY390, a 1956 Gardner-engined bus. It is leaving the bus station for Keynsham Park Estate. (*Geoff Lusher collection*)

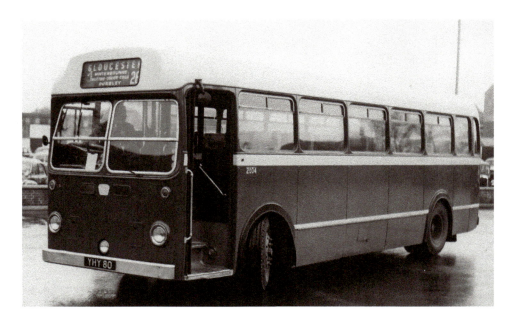

Bristol LS5G bus 2922, YHY80, was new in 1957 with forty-one dual-purpose seats in its ECW body, and was renumbered as 2004 in 1961, when a separate number block was allocated for dual-purpose vehicles. It received a cream roof in 1960. The more comfortable seats made the bus an ideal choice for operating the Gloucester (26) service. (*BVBG*)

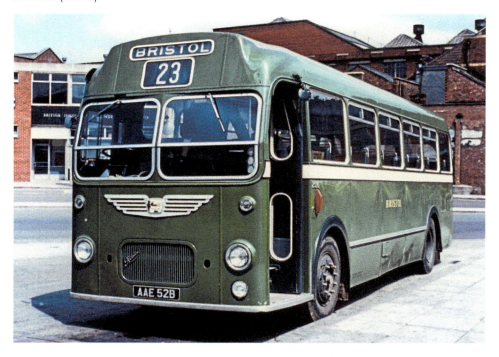

At Bristol bus station, and having arrived from Bridgwater on service 23, 1964 Bristol MW5G 2596, AAE52B, was built with the standard forty-five-seat ECW body. (*BVBG*)

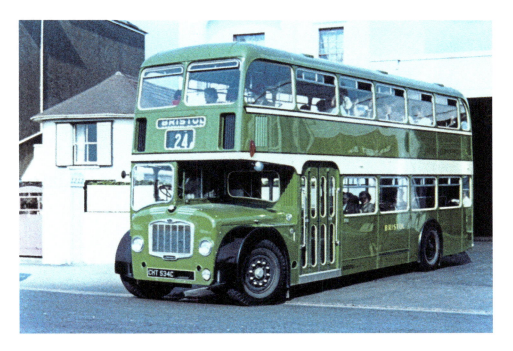

Over seventy Bristol Lodekka FLF seventy-seat buses were delivered to the Bristol company in 1965 for their various fleets. With the paintwork on its ECW body gleaming, country services Bristol-engined 7171, CHT534C, departs the Weston-super-Mare seafront bus station for Bristol. (*BVBG*)

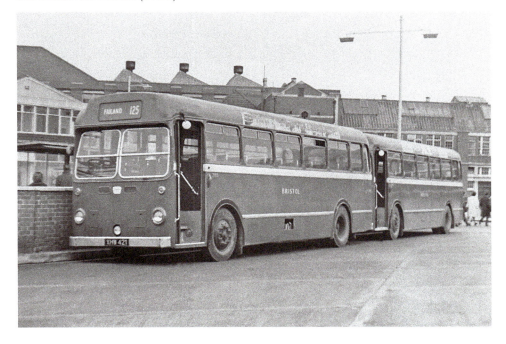

2905 and 2907, XHW421 and 423, were Bristol LS5Gs new in 1957, both with forty-five-seat ECW bodies. They are parked up outside Bristol's bus station in October 1965. (*Mike Walker*)

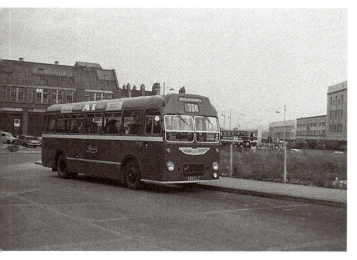

Loading outside of the entrance to the bus station, 2966, 986DAE, is a Bristol MW5G from 1959. At the time of this November 1965 view, the 38E service to South Widcombe, in the Chew Valley, ran twice on Saturdays only. By this time the bus had received the new Bristol scroll fleetname on the side of its ECW forty-five-seat body. (*Mike Walker*)

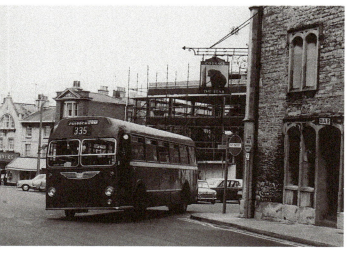

2968, 988DAE, a forty-five-seat ECW-bodied Bristol MW5G, new in 1959, enters Chippenham at the end of its journey eastwards from Bristol via Wick and Marshfield. (*Geoff Lusher collection*)

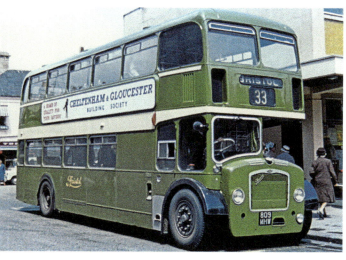

Off-side illuminated advertisement panels were fitted from new to a number of ECW-bodied seventy-seat Bristol FLF buses, as shown by 1961 bus 7014, 809MHW, which is pictured later in its life when displaying the scroll fleetname. (*BVBG*)

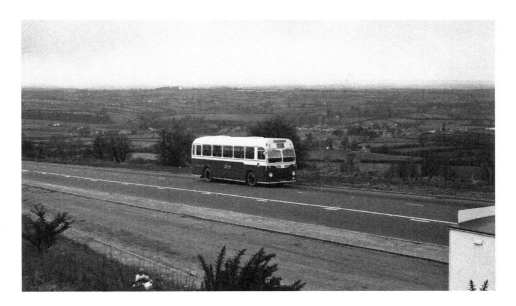

1966 was the last year that Bristol MWs were taken into stock, and the 1966 ECW-bodied forty-one-seat dual-purpose vehicles were unusual in having six-cylinder Gardner engines, rather than the normal five-cylinder. Looking quite new, 2030, HAE262D, climbs Tog Hill outside of the city boundary to the east, heading for Marshfield; however, it has few takers for its more luxurious seats. (*Deryck Ball*)

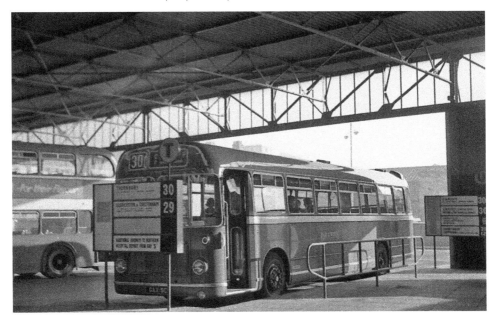

Three Red & White Services 1965 fifty-four-seat ECW-bodied Bristol RELL saloons were loaned to the company for the new Severn Bridge service; R565, GAX5C, stands at Marlborough Street bus and coach station within a few days of the commencement of the service. It is ready to depart for Cardiff and displays the 'on hire' sticker just above the nearside sidelight. (*Mike Walker*)

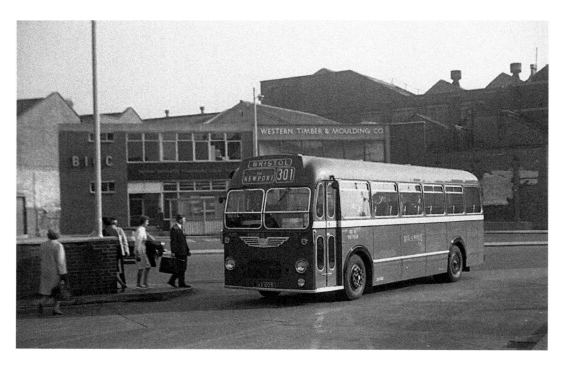

JAX102D, a 1966 ECW-bodied Bristol MW of Red & White Services arrives at Bristol at the end of a service 301, limited-stop journey from Cardiff in September 1966. (*Mike Walker*)

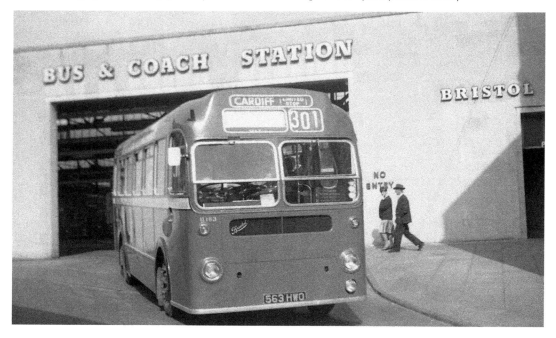

Leaving the bus station for Cardiff is 1964 Red & White Services ECW-bodied Bristol MW U163, 563HWO. The front-grill arrangement was unusual and not seen on the Bristol company's MWs. (*Mike Walker*)

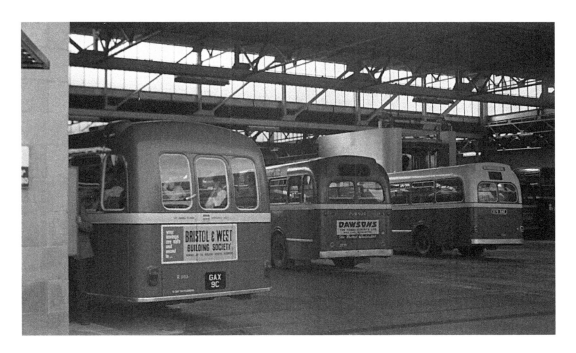

The arrival of the 1965-built Red & White Bristol RE buses allowed for this comparison of ECW single-deck rear ends over the years. The dual-purpose Bristol MW to the right dates from 1963, while the Bristol LS in the centre was new in 1954. (*Mike Walker*)

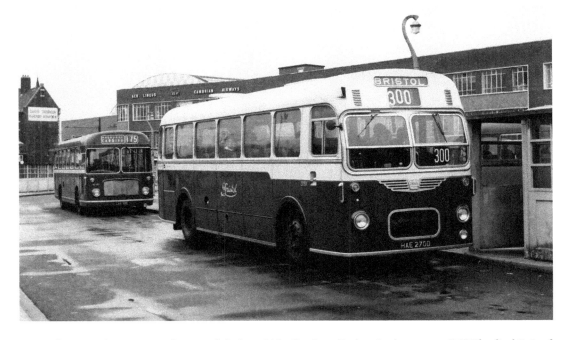

The Bristol company often used their 1966-built, six-cylinder, dual-purpose, ECW-bodied Bristol MWs on the services to Cardiff. On a wet June day in 1967, 2038, HAE270D, prepares to depart from Cardiff bus station for its home city on the stopping 300 service. (*Geoff Lusher collection*)

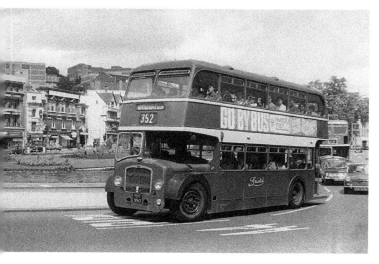

On a Sunday in July 1968, ECW-bodied Bristol LD L8434, YHT950, leaves Broad Quay, central Bristol, operating a heavily laden duplicate journey to the seaside. It had been new in 1957 with an open platform for use on Western-super-Mare town services. (*Graham Jones*)

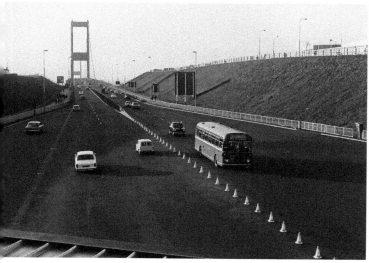

For the first few years after the opening of the Severn Bridge, tolls were collected in both directions. A Red & White 1965 ECW-bodied Bristol RELL approaches the England-side tolls on its way to Bristol on the limited-stop 301 service, with the full splendour of the new bridge as a backdrop. (*David Johnson*)

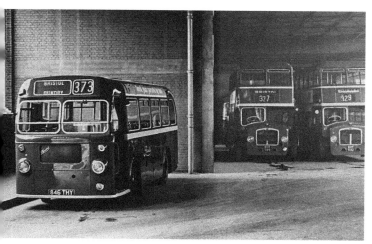

The small number of the diminutive thirty-seat ECW-bodied Bristol SUS buses allocated to Bristol country services were usually found on the Dundry route, renumbered in 1966 from 80 to 373. The Dundry service timetable of the period related the story that the church at Dundry was the third produced by the local Somerset craftsman, who then declared, 'I've done dree (three)'! (*Geoff Lusher collection*)

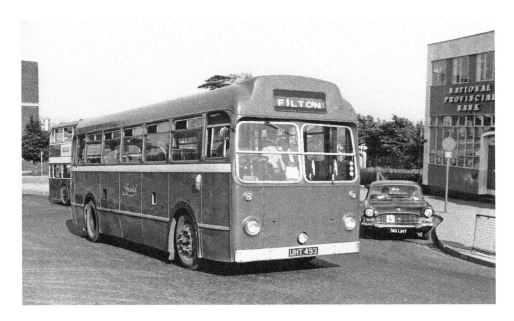

One of two experimental ECW-bodied Bristol LS buses, 2883, UHT493, acquired from Bristol Commercial Vehicles, is operating with a conductor at Filton Church in this June 1968 view. (*Graham Jones*)

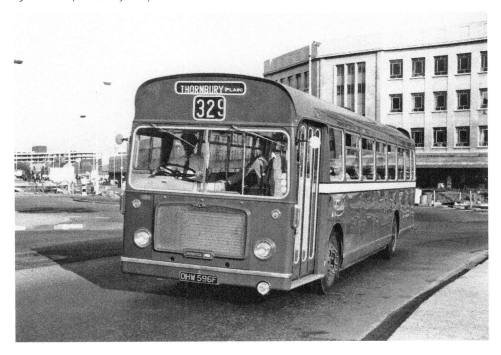

The ECW-bodied fifty-three-seat Bristol RELL6L buses, new to Bristol country services in 1968, entered service on conductor-operated routes. The conductor can be clearly seen in this August 1968 view of 1084, OHW596F, which was only a few months old at the time. (*Graham Jones*)

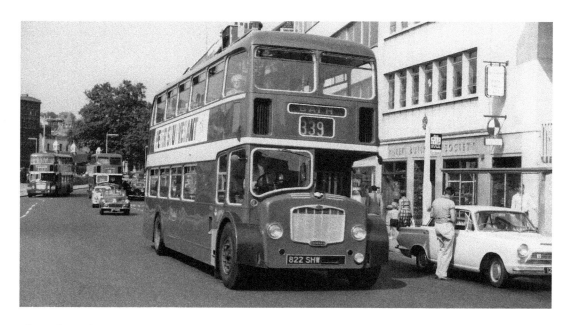

The only Leyland-engined ECW-bodied Bristol FLF for country services was regularly used on the 339 service to Bath alongside similar buses fitted with Bristol or Gardner engines. In August 1968 it travels along Broad Quay towards Queen Square – cars parked on bus stops are nothing new! (*Graham Jones*)

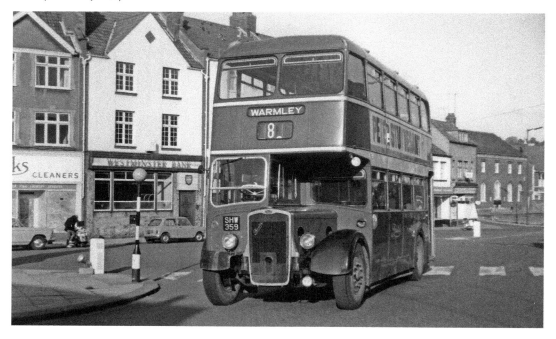

Country buses allocated to Lawrence Hill depot often worked BJS routes, especially near the end of their lives, and often for mileage-balancing purposes. In November 1968 ECW-bodied Bristol KSW6G 8189, SHW359, new in 1955, passes through Westbury-on-Trym village on the city's most frequent and busiest route, 8/8A. (*Graham Jones*)

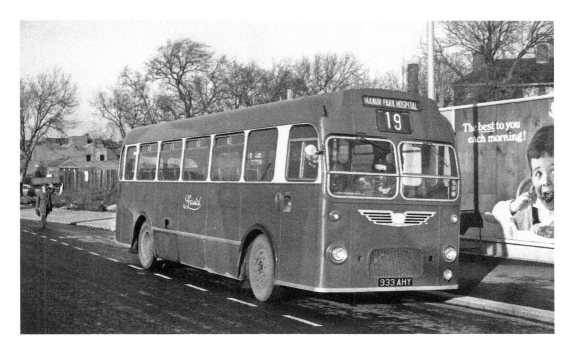

Conductor-operated 1958 ECW-bodied Bristol MW 2943, 933AHY, operates an extra journey on BJS service 19, although most journeys on this service were by this operated without a conductor. Broad Street, Bristol, December 1968. (*Graham Jones*)

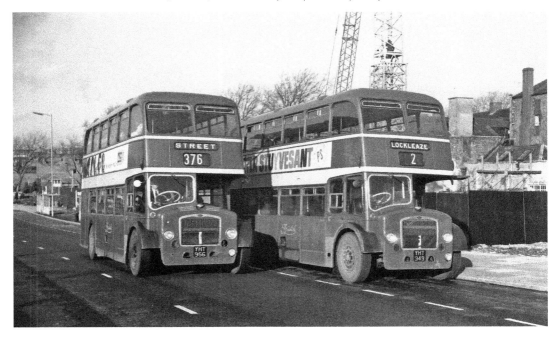

Both of these ECW-bodied Bristol LDs, seen here at Old Market, central Bristol, in December 1968, were country service buses. L8460, YHT956, is operating to Wells, Glastonbury and Street, while L8433, YHT949, is on BJS service 2. (*Graham Jones*)

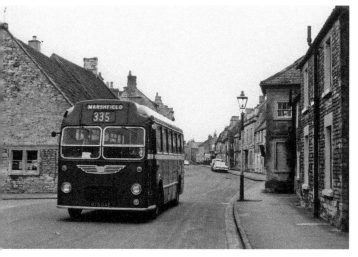

1959 ECW-bodied Bristol MW5G 2955, 975DAE, winds its way in May 1969 through the pretty Cotswold stone village of Marshfied, east of Bristol and regularly connected to it by service 335. (*Geoff Lusher collection*)

The company received a large batch of Bristol RELL6L saloons in 1967; fifty-three-seat ECW-bodied 1048, MHW852F, was one of around sixty delivered that year. In 1969 the bus climbs out of Wotton-under-Edge towards Stroud on the 400 service. (*Deryck Ball*)

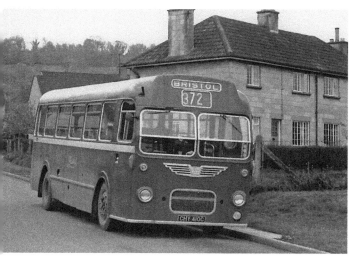

During the 1960s, the ECW-bodied Bristol MW5G was ubiquitous throughout the Bristol country area. 1965 bus 2617, CHY410C, rests at Bishop Sutton in the Chew Valley, south of Bristol, ready for the return to Bristol. (*Geoff Lusher collection*)

Right: Thankfully accidents are rare: 1959 Bristol LD6B Lodekka L8489, 854CHU, suffered roof damage to its ECW body when it struck a low bridge between Frenchay and Filton whilst running empty between timetabled journeys in June 1969. Remarkably, it returned to Bristol from Filton on service! (*Mike Walker*)

Below: 1958 ECW-bodied Bristol LS5G YHY85, 2927, loads at College Green, central Bristol, outbound for Nailsea in August 1969. (*Mike Walker*)

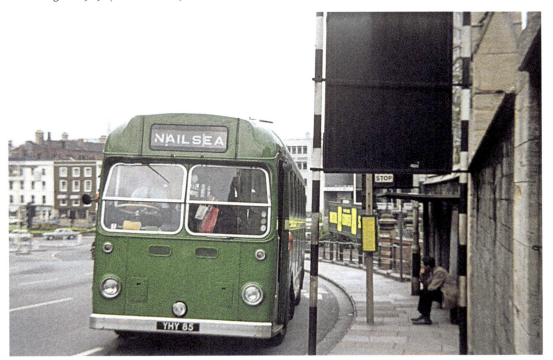

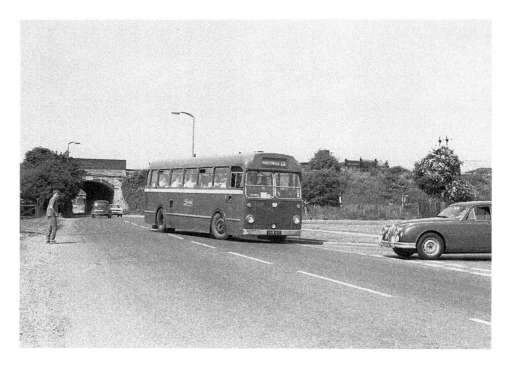

Approaching the end of its life, ECW-bodied 1956 Bristol LS5G 2885, XHW401, turns into Little Stoke, north Bristol, heading for Northwick near Pilning on service 330. (*Deryck Ball*)

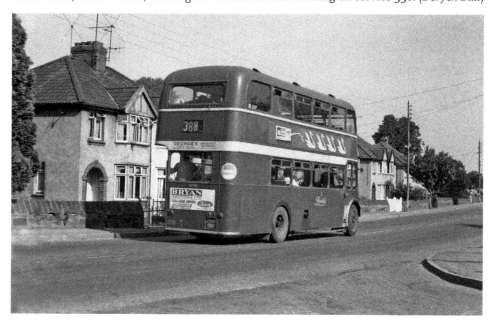

The 388 service connected the estates to the east of Bristol that were outside of the BJS network with Bristol bus station – it was normally operated by Hanham depot. BJS 1953-built sixty-seat ECW-bodied Bristol KSW C8136, PHW961, speeds through Warmley at some time in 1969. (*Deryck Ball*)

Heading in the opposite direction at Warmley on Hanham local service 382 is 875RAE, 2560, a standard ECW-bodied forty-five-seat Bristol MW5G, new in 1962. (*Deryck Ball*)

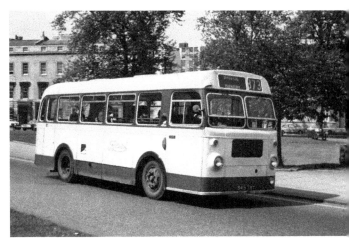

In February of 1968 ECW-bodied Bristol SUS 305, 845THY, received the brighter livery associated with the city's 'City Centre Circle' service, although it is believed it never actually operated on that route. The bus is shown passing through Queen Square, central Bristol, outbound for Dundry. (*Geoff Lusher collection*)

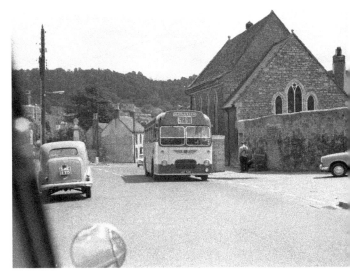

2596, AAE52B, an ECW-bodied Bristol MW5G of 1964, pauses at Wotton-under-Edge, Gloucestershire, on a journey to Gloucester in 1969. By this time the bus had acquired the new, lighter livery to denote a one-person operated bus, although the 526 route still carries a conductor, who can be seen talking to the villager sat on the bench. (*Deryck Ball*)

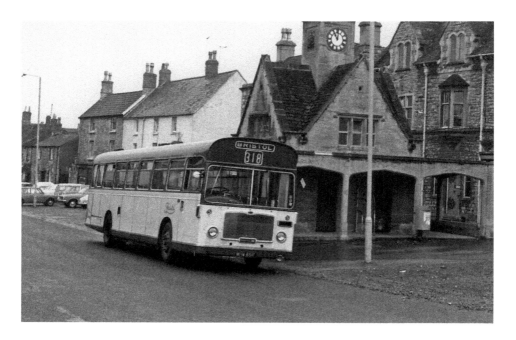

1047, MHW851F, an ECW-bodied Bristol RELL6L from 1967, is in the brighter livery for one-person-operated buses, and waits at Chipping Sodbury Clock Tower for a return journey to Bristol. (*Phil Sposito*)

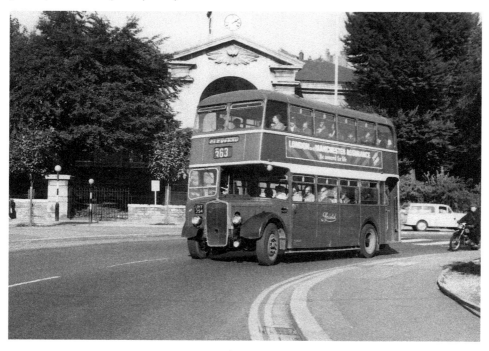

UHY394, 8346, an ECW-bodied Bristol KSW6G from 1956, is fully laden as it heels over while cornering at Hotwells, Bristol, outbound for Clevedon in October 1969. (*Graham Jones*)

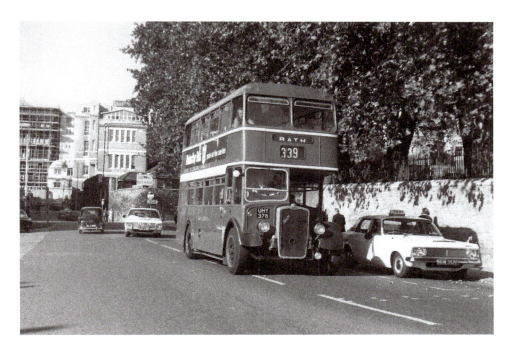

Having just left Bristol bus station, 1955 ECW-bodied Bristol KSW6G UHY378, 8267, of the Bath Services fleet, heads home on an October day in 1969. (*Graham Jones*)

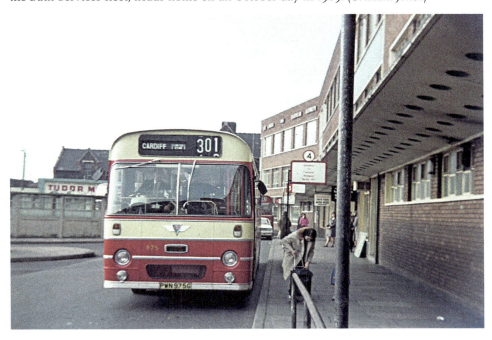

For a short period in late 1969, this South Wales Transport Marshall-bodied AEC Reliance was on loan to the Bristol company in exchange for dual-purpose vehicle 2056 in connection with saloon-heating trials. 975, PWN975G, is shown in Cardiff in November 1969. (*Mike Walker*)

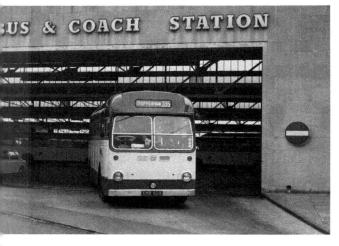

1957 ECW-bodied Bristol LS5G 2912, XHW428, leaves Bristol bus station in April 1970 for a journey eastwards to Chippenham on service 335. The following year the bus was rebuilt, re-engined and renumbered 3003. (*Deryck Ball*)

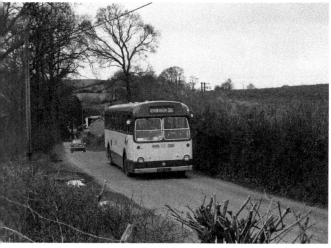

2907, XHW423, a similar Bristol LS5G bodied by ECW, heads deep into the Gloucestershire countryside on its way to Severn Beach on the River Severn in April 1970. In 1972, this bus was also rebuilt, to become 3007. (See p. 67) (*Deryck Ball*)

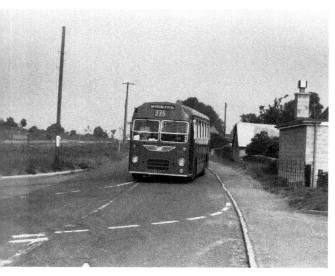

The driver of 1958 ECW-bodied forty-five-seat Bristol MW5G 2940, 930AHY, pulls hard on the steering wheel to get his bus around this tight bend at Biddeston in Wiltshire, returning to Bristol on a journey from Marshfield in May 1970. (*Deryck Ball*)

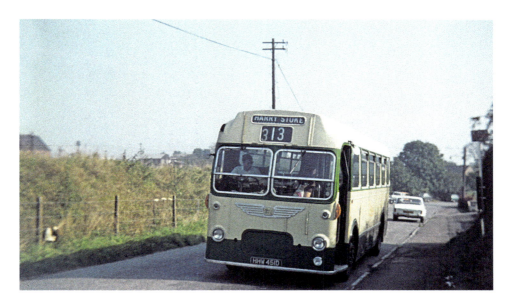

The Harry Stoke terminus of service 313 from Bristol was close to the London–South Wales railway line and also to the housing developments taking place at the northern end of the city beyond Filton – it was one of the shortest country routes from the bus station. 2635, HHW451D, was the last-but-one ECW-bodied Bristol MW5G to be bought by the company, and was painted into this brighter colour scheme for use on Bristol's City Centre Circle service – hence the brackets either side of the destination screen and above the headlight to take that service's special headboards. (*Mike Walker*)

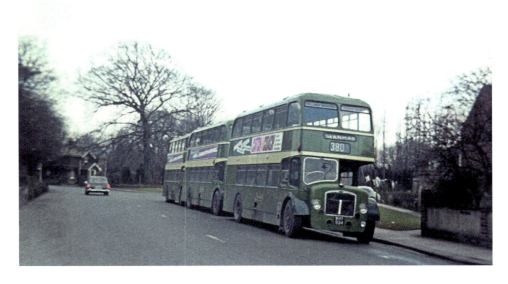

In March 1971 Hanham local service 380, running between Hanham and Frenchay, around the eastern fringes of the city, operated at a 15-minute frequency, more akin to a city service. At the Frenchay terminus, 1956 ECW-bodied fifty-eight-seat Bristol LD6G Lodekka L8393, WHY934, heads a line of similar vehicles. (*Mike Walker*)

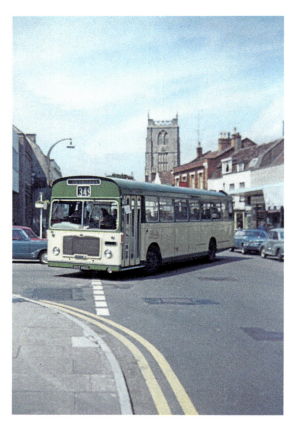

Left: In June 1971 ECW fifty-three-seat Bristol RELL6L RHT146G, fleet number 1097, new in 1968, turns from Keynhsam town centre towards Park Estate on service 349. (*Mike Walker*)

Below: In June 1972 BJS two-doorway ECW-bodied forty-four-seat Bristol RELL6L C1219, AHT203J, stands at Keynsham, having arrived on Hanham local service 383. (*Mike Walker*)

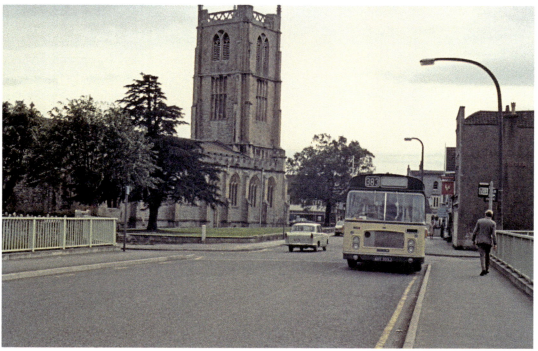

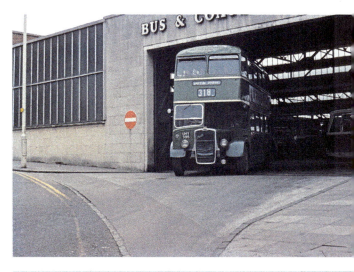

In this April 1972 view, a journey on the Chipping Sodbury (318) service is being operated by 1956-built sixty-seat ECW-bodied Bristol KSW6G 8347, UHY395, the last but two of this type for country services. (*Mike Walker*)

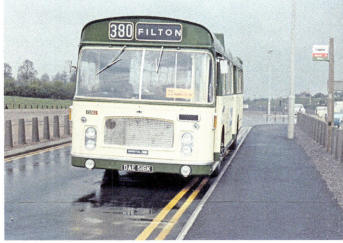

In April 1972 British Rail opened a new station, Bristol Parkway, north of Bristol at the junction of the Bristol–Gloucester and Cardiff–London railway lines. The company extended Hanham local service 380 westwards from Frenchay to serve the station and terminate at nearby Filton. BJS Bristol RELL6L C1262, DAE516K, with an ECW forty-four-seat dual-doorway body, was on display at the opening ceremony to publicise the new connections. (*Mike Walker*)

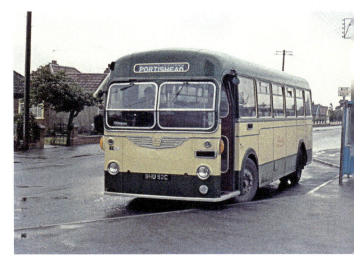

A 1965 batch of seven ECW-bodied thirty-nine-seat Bristol MW6G coaches were relegated to bus work after six years, although they retained their coach seating. 2428, BHU92C, which had been coach 2138, stands at Portishead on the Bristol Channel coast, having arrived on a Clevedon local service in May 1972. These seven vehicles never received full destination displays. (*Mike Walker*)

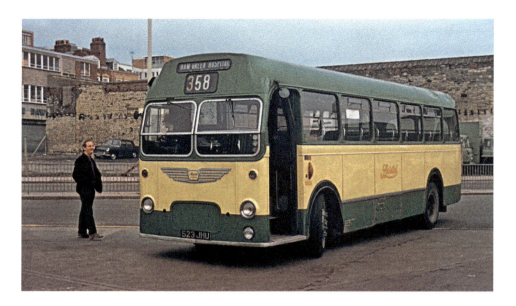

On Boxing Day in 1972, when services did not normally operate, a number of hospital journeys were trialled. 2501, 523JHU, a 1960 ECW-bodied Bristol MW5G, pulls into Bristol bus station to operate to Ham Green Hospital. Talking to the driver is Ken Forrister, who, as Divisional Traffic Superintendent (Bristol), was at that time responsible for Bristol country buses. (*Alan Walker*)

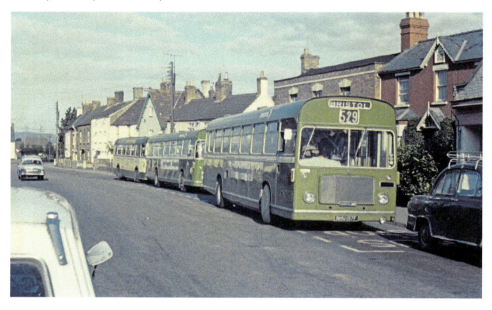

By the date of this photograph in August 1973 the Bristol–Cheltenham service (529) had been cut back to operate between Bristol and Gloucester, although the buses still met in Berkeley and drivers changed over there. The yellow-and-white fleet number plate on 1063, NHU197F, indicates that this is a Northern Division, Gloucester-based bus; it is a fifty-three-seat ECW-bodied Bristol RELL6L, as is the Gloucester-bound bus behind. The MW is on a connecting local service. (*Mike Walker*)

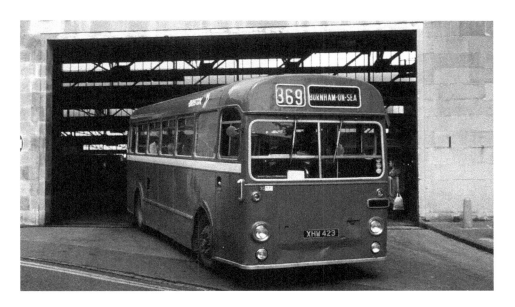

A number of ECW-bodied Bristol LS saloons were rebuilt and fitted with six-cylinder engines at the end of their normal life. XHW423 had been 2907 but became 3007 on rebuilding, and sported cream window rubbers and a revised front end; it was to be the last to be rebuilt, due to the introduction of the 'New Bus Grant', which dramatically reduced the cost to the operators of new buses. The bus is shown departing Bristol bus station for Burnham-on-Sea on service 369, which had replaced the once double-deck operated route to Bridgwater. (See p. 62) (*Geoff Lusher collection*)

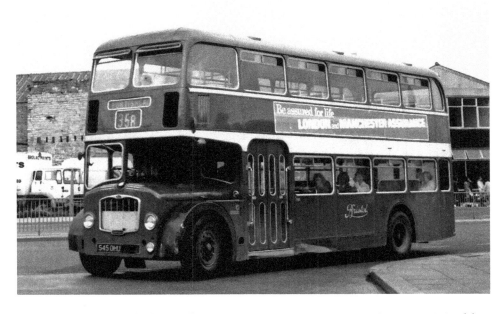

Seventy-seat ECW-bodied Bristol FLF6B 545OHU, 7100, new in 1963, enters Bristol bus station from Portishead – with the destination blind already set for the return journey! (*Phil Sposito*)

67

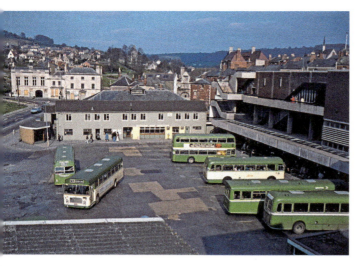

A number of Saturday-only limited-stop journeys were introduced during the early 1970s to allow people from towns and cities outside of Bristol to come into the city for shopping. An ECW-bodied Bristol RELL saloon leaves Stroud bus station for Bristol on the 702 service. (*Geoff Gould*)

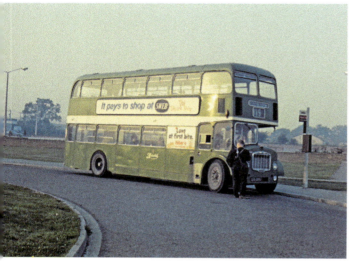

The white Bristol scroll fleetname and Bristol coat of arms identifies 1962 ECW-bodied seventy-seat Bristol FLF6B C7070, 515OHU, as a BJS bus. Seen here at Yate Shopping Centre in August 1974, the bus is preparing for a journey to Bristol via Westerleigh as service 319. (*Mike Walker*)

For some years Bristol depot's Clevedon outstation was based in Clevedon quarry. Rebuilt Bristol LS6G 3007, YHY74, and Bristol MW5G 2580, 940RAE, both with ECW bodies, are parked up here in 1975. (*Mike Walker*)

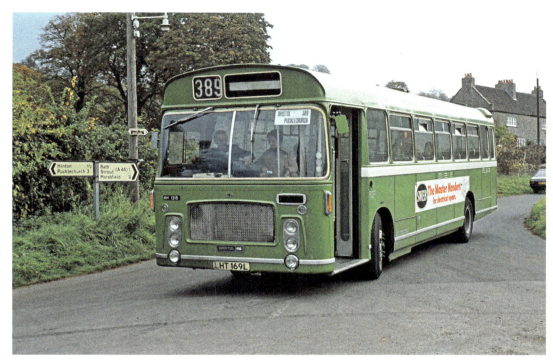

Above: 1973-built ECW-bodied fifty-seat Bristol RELL6L LHT169L, 1315, pauses to load passengers at Dyrham east of Bristol and Pucklechurch, late in 1975. (*Geoff Gould*)

Right: 1968 ECW-bodied fifty-three-seat Bristol RELL6L RHT144G, 1095, climbs out of Chewton Mendip in Somerset on its way to Bristol on service 376 in August 1976. (*Geoff Gould*)

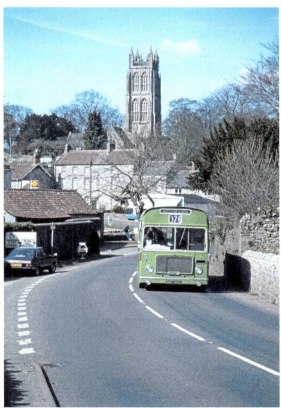

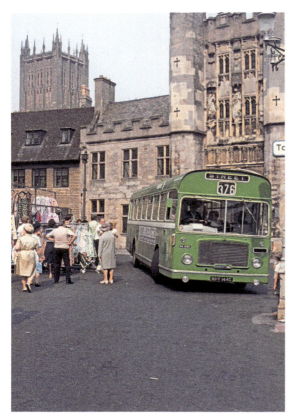

Left: 1095, RHT144G, an ECW fifty-three-seat Bristol RELL6L, new in 1968, struggles to get through Wells Market Place on its way to Glastonbury and Street on a market day in August 1976. In due course the service was removed from serving this particular stop because of this problem. (*Geoff Gould*)

Below: New as a Bristol Greyhound coach in 1968, 2156, NHW313F, was a forty-five-seat ECW-bodied Bristol RELH6L. By October 1976 it had been renumbered 2084 and painted into dual-purpose livery, and is shown at Cardiff bus station, ready to return to Bristol on limited-stop service 301. (*Geoff Gould*)

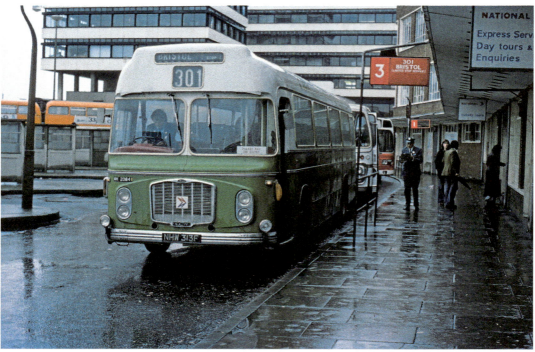

In April 1977 2596, AAE52B, an ECW-bodied forty-five-seat Bristol MW5G, has just turned in the reserved turning circle at the Harry Stoke terminus of service 313. (*Geoff Gould*)

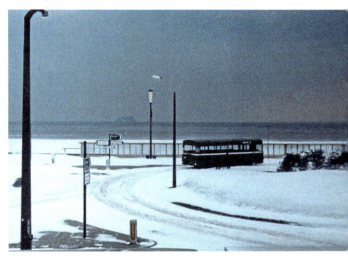

A heavy overnight snow fall on 19 February 1978 caused major disruption to buses in Weston-super-Mare. The first bus to Bristol on that Sunday morning was dispatched from the bus station with a manual gearbox Bristol LH6L (instead of a semi-automatic Bristol RE); a crew of two, a sandbag and a shovel! This photograph, taken from the bus station office window, shows just how far it got before having to be dug out! Eventually, the 60-minute journey took two-and-a-half hours! (*Mike Walker*)

REU327S, 416, from the 1978 batch of ECW-bodied Bristol LH6L saloons, leaves Winford and approaches the A38 close to Lulsgate and Bristol Airport while on its way to the Somerset coast in March 1978. (*Graham Jones*)

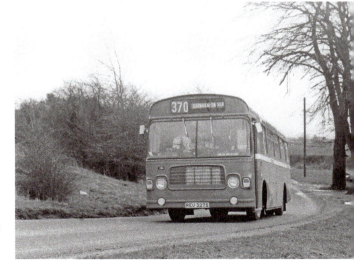

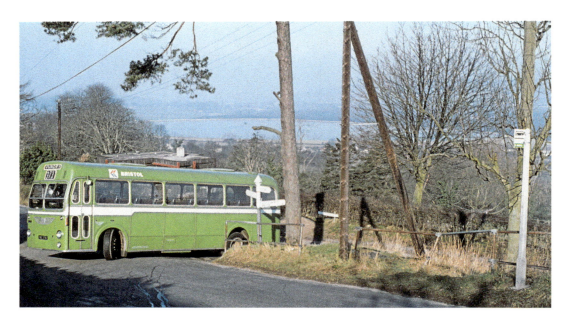

With the withdrawal of the small Bristol SUS, the Dundry service was operated by Bristol MW saloons: 2434, HAE271D, former dual-purpose 2039, negotiates the infamous hairpin bend between Bristol and Dundry in March 1978 with 'Barrow Tanks', Bristol's water supply reservoirs, in the background. (*Geoff Gould*)

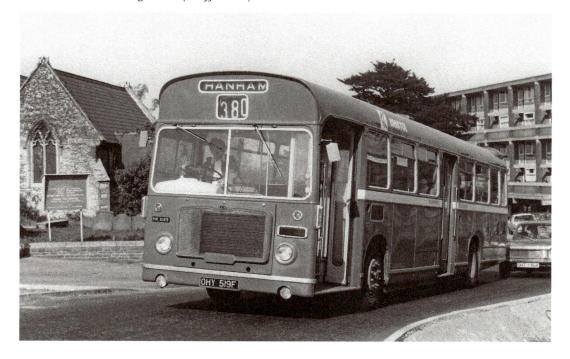

1968 ECW-bodied Bristol RELL6L OHU519F, 1089, was new as a single-door bus but was converted to a dual-door layout for service in Bath. By May 1978 it had migrated to Hanham depot and is shown at Filton on service 380. (*Graham Jones*)

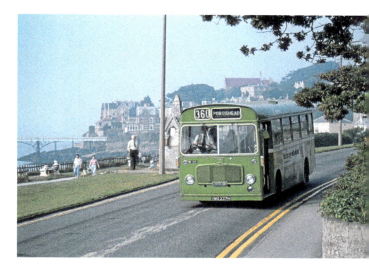

In 1977 the company acquired five early ECW-bodied flat-screened Bristol LH6L buses from the Thames Valley & Aldershot Omnibus Co., of which 346, VMO227H, was one. It is seen at Clevedon, operating local service 360 to Portishead in July 1978, with the Victorian Clevedon Pier in the background. (*Geoff Gould*)

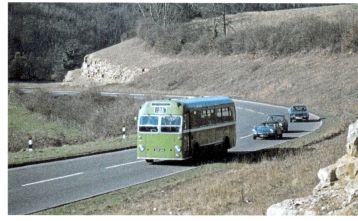

There had been a considerable reduction in services into rural areas by March 1978. However, 1964 ECW-bodied forty-five-seat Bristol MW5G 2590, 983UHW, makes its way to Chippenham. (*Geoff Gould*)

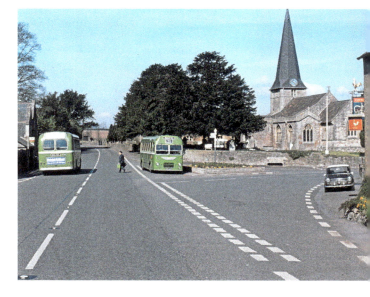

Services shared between two depots sometimes needed a crew swap to ensure that drivers ended up at their home depot, even if the vehicle did not. This was the case in West Harptree, in the Chew Valley, in this April 1978 view of two 129 (Bath–Weston-super-Mare) ECW-bodied Bristol MW5G buses, although similar changeovers took place on Bristol country services. (*Geoff Gould*)

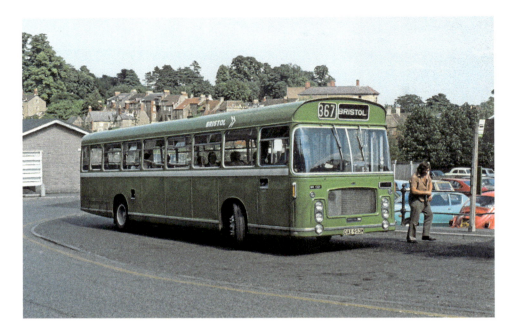

1973 was the last year that the company received ECW-bodied Bristol RELL buses, and 1331, OAE953M, was part of the last batch of ten. Shown here in Frome in July 1978, the bus would have worked from Bristol to Shepton Mallet as a 377, and Shepton Mallet to Frome as a 262; it is about to return to Bristol as the 367 service. (*Geoff Gould*)

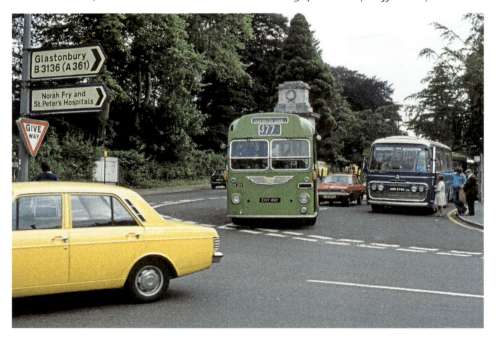

Leaving Shepton Mallet's Cenotaph terminus for Farrington Gurney in August 1978 is 2618, CHY411C, a 1965 ECW-bodied forty-three-seat Bristol MW5G. The 377 service nominally operated to Bristol, but this short working was operated by Wells depot. (*Geoff Gould*)

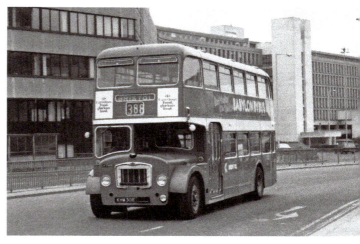

With the cessation of the BJS agreement in July 1978, the BJS (city) fleet became company owned. 7309 (formerly C7309), KHW301E, from the final 1967 batch of ECW-bodied seventy-seat Bristol Lodekka FLF6B buses, enters Bristol's bus station on the 388 service from Bitton, part of the Hanham-based network. (*Phil Sposito*)

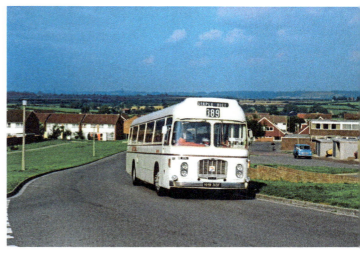

1968 former Bristol Greyhound ECW-bodied Bristol RELH6L NHW313F, 2156, was numbered in the dual-purpose series as 2084. This was despite having been repainted into National coach livery by September 1978, which is when it was seen here in Pucklechurch, operating a short working on the Bristol 389 service. (*Graham Jones*)

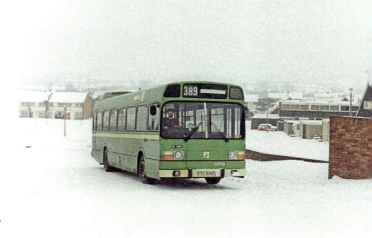

From 1974 the company's requirement for large single-deckers was met by the Leyland National. After a heavy snowfall in January 1979, 1978 fifty-two-seat 3066, TTC534T, gingerly ascends Oaktree Avenue, Pucklechurch, on the Bristol 389 service. (*Graham Jones*)

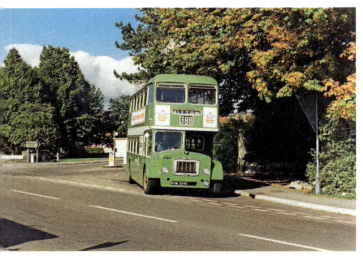

1967 ECW-bodied Bristol FLF6B 7312 (formerly C7312), based at Hanham depot, leaves Cherry Gardens for Bitton on service 388. This was before the service was absorbed into the new city network, following the cessation of the BJS agreement. (*BVBG*)

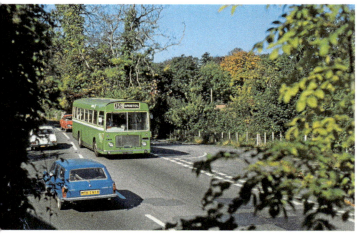

Seen descending Rownham Hill from Portishead on its way to Bristol in October 1978 is 1969 ECW-bodied forty-three-seat Bristol RESL6L 510, THU356G. (*Geoff Gould*)

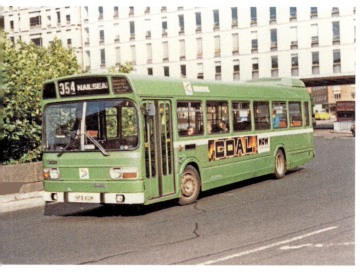

Fifty-two-seat Leyland National NFB601R, 3033, from 1976, rounds central Bristol's St James Barton roundabout, en route for Nailsea. (*BVBG*)

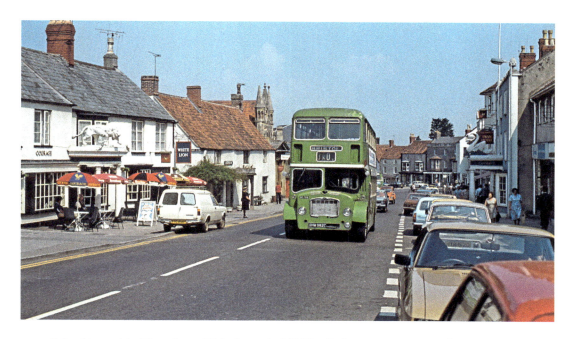

Bristol-bound in Thornbury High Street is ECW-bodied seventy-seat Bristol FLF6G DHW982C, 7212, new in 1965. The traffic warden in the background appears to be awaiting the return of the van driver! *(Geoff Gould)*

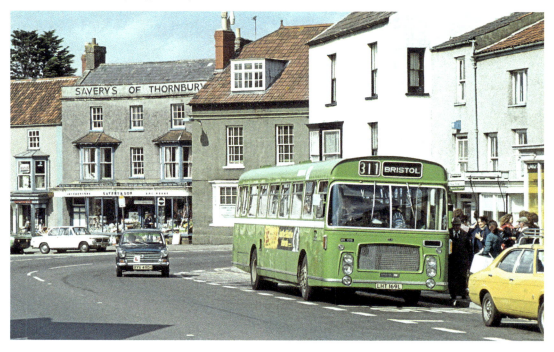

At the lower end of Thornbury High Street in 1973, ECW-bodied fifty-seat Bristol RELL6L LHT169L, 1315, loads for Bristol, having arrived from Sharpness on the banks of the River Severn. (*Geoff Gould*)

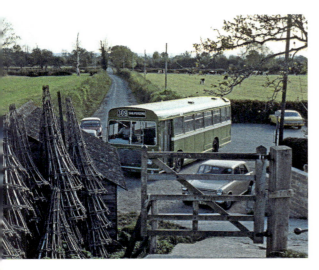

Parked cars make difficulties for the driver of 1969-built ECW-bodied forty-three-seat Bristol RESL6L THU358G, 512, as he turns at the Shepperdine terminus of Thornbury local service 309. (*Geoff Gould*)

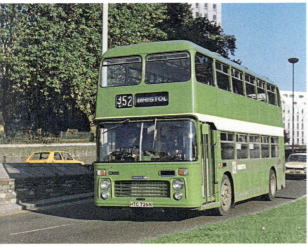

The company's first single-door ECW-bodied Bristol VRTs were new in 1975 and were allocated to Weston-super-Mare depot with the intention of using them on the busy Bristol (352) service; however, a disagreement with the staff representatives over the applicable rate of pay postponed this conversion for some years. 5500, HTC726N, operates the service in central Bristol in November 1979, albeit with a conductor on board. (*Graham Jones*)

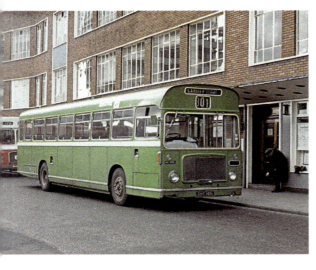

1968 ECW-bodied fifty-three-seat Bristol RELL6L 1092, RHT141G, rests at Cardiff bus station in February 1980. (*Mike Walker*)

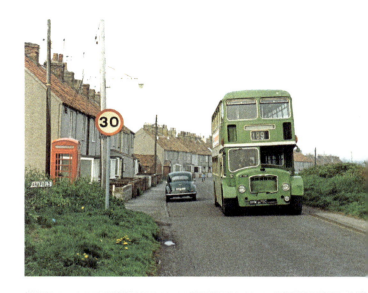

The Parkfield Rank terminus of service 389 from Bristol was at this line of former miners' cottages, built in 1853. Although nominally allocated one-person-operated saloons, an afternoon schools journey was double-deck operated – in this case, in May 1980, by 1965 ECW-bodied seventy-seat Bristol FLF6G BHW675C, 7183. (*Graham Jones*)

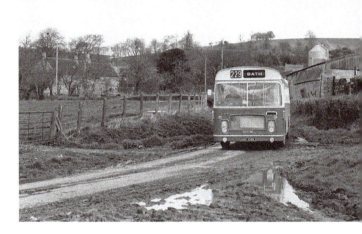

Although numbered in the Bath area series, service 229 from Yate to Bath was operated by Marlborough Street depot. In April 1980 ECW-bodied Bristol RELH6L forty-nine-seat dual-purpose GHY138K, 2076, new in 1972, passes through Dyrham (not a farmyard!) on its way to Bath. (*Graham Jones*)

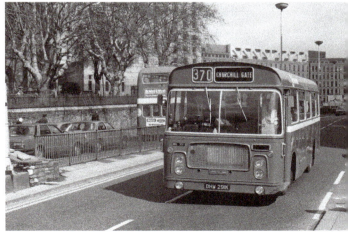

The company's first ECW-bodied Bristol LH6L buses were six forty-two-seat semi-automatic buses new in 1972 and spent almost their entire lives at Weston-super-Mare or Wells depots. However, towards the end of their life, at least 351 was moved to Bristol and is seen operating southwards to Churchill Gate on the A38 in March 1980. (*Graham Jones*)

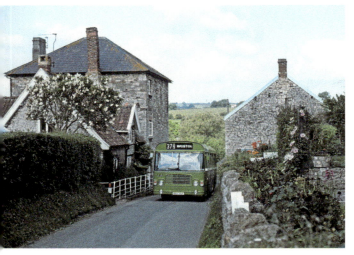

Between 1975 and 1980 the company took delivery of over 100 lightweight ECW-bodied forty-three-seat Bristol LH6L saloons, principally for rural services. In June 1980 REU331S, 420, new in 1978, squeezes through Woollard, heading for Bristol. (*Geoff Gould*)

By 1980 Wells depot operated all of the service 376 workings, and in July 1980 were using former BJS two-doorway ECW-bodied Bristol VRTbus 5050, LEU258P, new in 1976, at the behest of the advertiser, Wimpey Homes. The bus is shown loading at Wells bus station for a journey to Bristol. (*Mike Walker*)

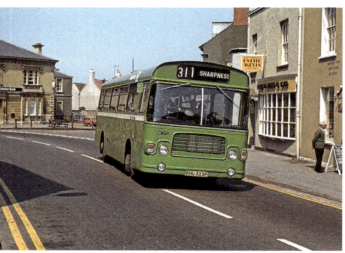

The ECW-bodied Bristol LH6L buses were ideal for more lightly loaded rural routes: 375, KHU325P, dating from 1976, leaves Thornbury for Sharpness on the Severn Estuary. (*Geoff Gould*)

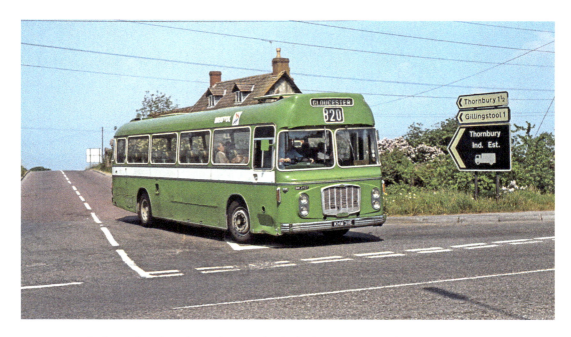

Towards the end of their lives, the 1967-built dual-purpose ECW-bodied forty-seven-seat Bristol RELH6L vehicles received standard bus livery. 2437, KHW311E, new as 2042, leaves Thornbury for Gloucester on limited-stop service 820. (*Geoff Gould*)

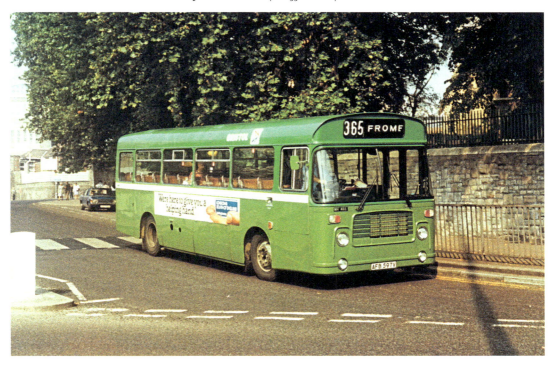

New in 1980, AFB597V, 466, was the company's last ECW-bodied Bristol LH6L saloon, and was sold in the spring of 1981. It is shown having left Bristol's bus station for Frome. (*BVBG*)

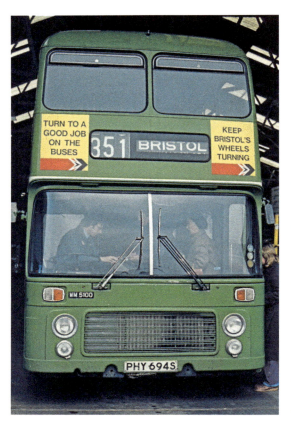

Left: Following a major service revision in Bristol and a reduction in vehicle requirements, the need for double-deck buses on the Bristol–Weston-super-Mare route was mostly met by the transfer of dual-doorway ECW-bodied Bristol VRTs from the former BJS fleet to Weston-super-Mare depot. 5100 (new in 1977 as C5100), PHY694S, loads at Weston-super-Mare's bus station and depot in April 1981 for a journey to Bristol: the driver is very youthful-looking Bristol expert and author Martin S. Curtis. (*Mike Walker*)

Below: Former Bristol Greyhound NHW312F, 2083, is also leaving Weston-super-Mare's seafront bus station and depot in April 1981, but this time for Swindon. It was new as 2155, an ECW-bodied Bristol RELH6L. (*Geoff Gould*)

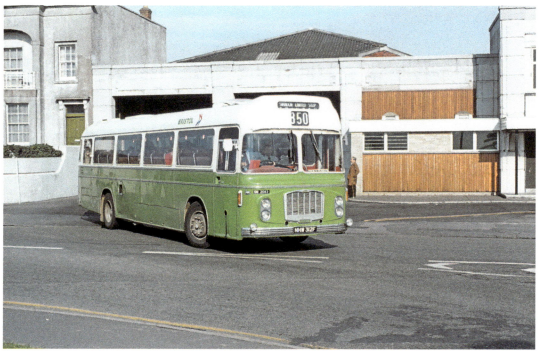

Another former coach to be downgraded to dual-purpose status was EHW313K; it was new in 1972 as 2161, but by April 1981 had been renumbered 2089. The Plaxton coachwork is mounted on a Bristol RELH chassis, fitted with a Gardner engine. The 830 service operated limited stop between Weston-super-Mare and Stroud, calling at Bristol bus station on the way. (*Geoff Gould*)

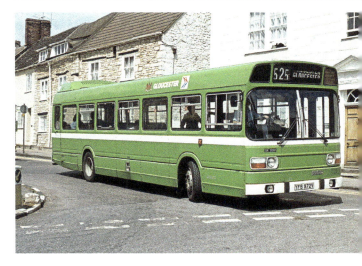

3081, YFB972V, was the last but one standard Leyland National new to the company, and entered service in December 1979 as G3081, part of the Gloucester City fleet. By July 1981, when photographed operating the Bristol–Gloucester (525) service, it had lost the G-prefix to the fleet number but still carried the Gloucester fleet name. (*Geoff Gould*)

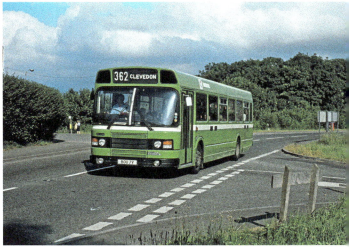

The last Leyland National 2 buses delivered to the company arrived in 1980, as represented here by 3532, BOU7V, which is at Cambridge Batch in July 1981, outbound for Clevedon. All of the company Leyland National 2 buses were new with fifty-two-seats and were powered by Leyland's TL11 engine. (*Geoff Gould*)

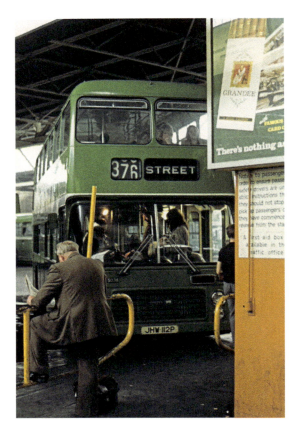

Left: Former BJS (city) ECW-bodied dual-doorway Bristol VRT JHW112P, 5038, loads inside Bristol's bus station while operating service 376 to Wells, Glastonbury and Street in June 1981. (*Mike Walker*)

Below: The last ECW-bodied Bristol VRT buses for the company were new in 1980, unusually with Leyland 0.680 engines. 5531, EWS739W, leaves Alexandra Parade, Weston-super-Mare, bound for Bristol, in August 1981. (*Mike Walker*)

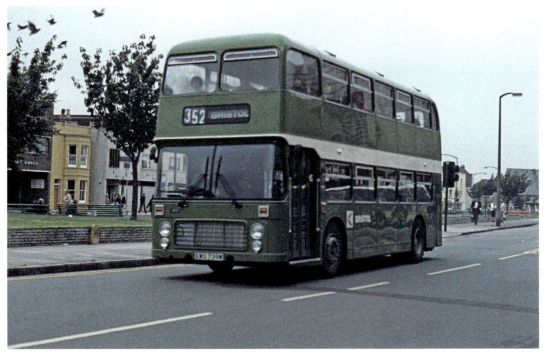

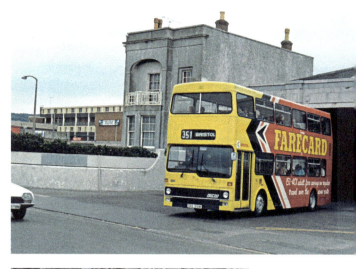

The Bristol company received five seventy-six-seat MCW Metrobuses in 1980 as part of a National Bus Company experiment: however, the BJS crews rejected them and they were allocated to Bath. In August 1981 6000, DAE510W, was loaned to Weston-super-Mare depot for the summer carnival and was worked back to Bath via Bristol on service 351. (*Mike Walker*)

Once the pride of the Bristol Greyhound coaching fleet, this 1961 ECW-bodied Bristol MW6G, 2113, 406 LHT, was cut down to a towing wagon after a twelve-year life. In November 1981 it tows Leyland National 2 3527, BOU2V, through Bristol's College Green, the bus having failed while returning from Portishead. (*Alan Walker*)

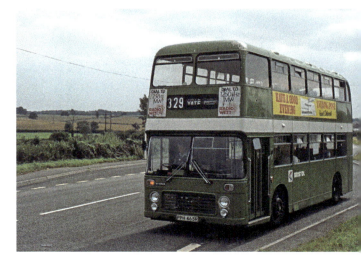

In 1980/81, the company acquired the entire batch of fifteen ECW-bodied Bristol VRTs from London Country Bus Services: they were built to a height of 14 feet 6 inches rather than the 13 feet 8 inches of most Bristol VRTs, and powered by Leyland's fixed-head 501 engine. PPH465R, 6504, makes its way to Yate on service 329. (*Geoff Gould*)

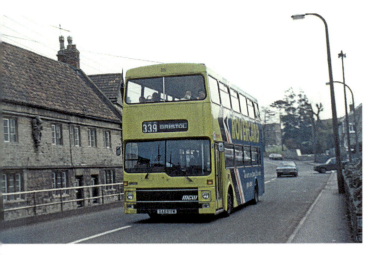

The whole batch of five 1980 Metrobuses were painted as overall advertisements for the company's range of off-bus ticketing, and were often to be found on the Bath–Bristol (339) service. In April 1982 6001, DAE511W, leaves Keynsham town centre on its way to Bristol. (*Alan Walker*)

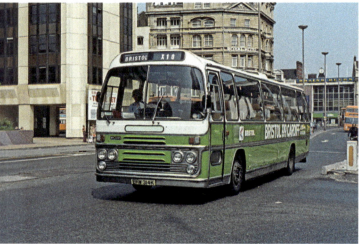

Photographed in Cardiff, 1972 Plaxton-bodied Bristol RELH6G EHW314K was new as coach 2162. Later in its life it became dual-purpose bus 2090 and received route branding for the Bristol–Cardiff limited-stop service, now numbered X10. By June 1982 the branding had been removed. (*Geoff Gould*)

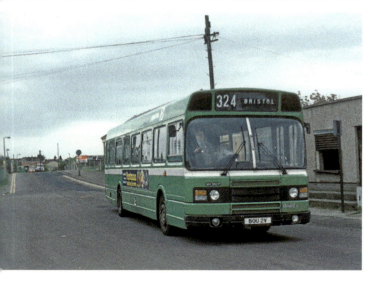

1980-built Leyland National 2 BOU2V, 3527, departs Severn Beach for Bristol on service 324 in April 1982. Behind the bus is Severn Beach railway station. (*Alan Walker*)

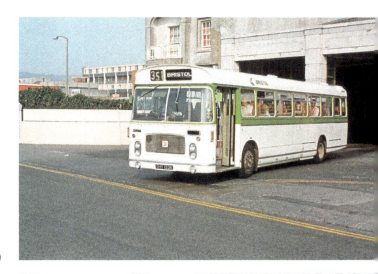

1972-built GHY133K, 2071, an ECW forty-nine-seat dual-purpose Bristol RELH6L, leaves Weston-super-Mare for Bristol on service 351 in September 1982. (*Geoff Gould*)

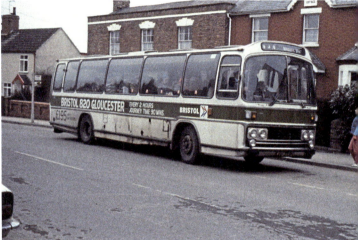

1976 Plaxton-bodied Leyland Leopard coach LEU273P was new as 2186 but was renumbered 2309 when transferred to local bus work. In 1981 it was painted white with a green waistband and then lettered for the limited-stop 820 service between Bristol and Gloucester. (*Geoff Gould*)

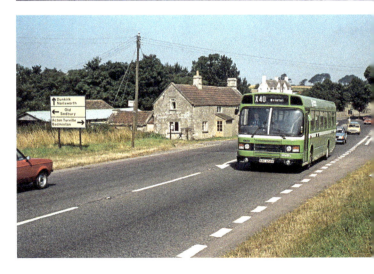

Close to Chipping Sodbury on the A46 and on its way to Bristol on the Saturday-only limited-stop service from Cirencester is 1980 fifty-two-seat Leyland National 2 AAE658V, 3514. X40 had been renumbered from 840. (*Geoff Gould*)

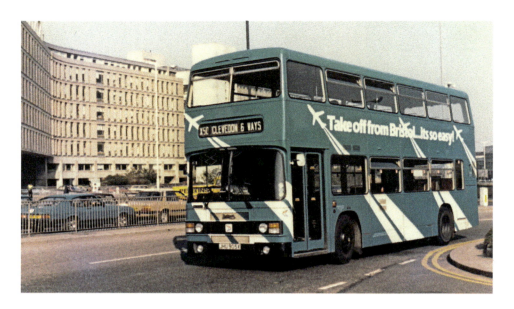

1982 Roe-bodied seventy-six-seat Leyland Olympian 9506, JHU905X, received a colour bus advertisement for Bristol Airport soon after delivery. The bus is shown entering Bristol's bus station with the new-style Transign destination display set for the limited-stop service to Clevedon. (*BVBG*)

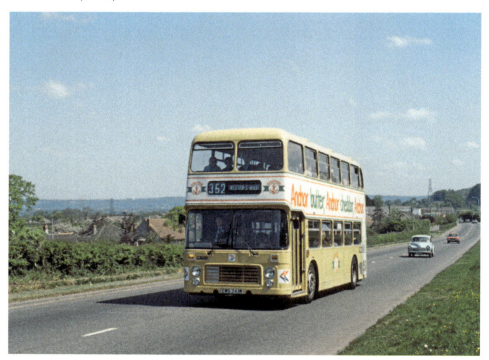

Climbing from Cleeve to Congresbury on the A370 in May 1984 is 1981 ECW-bodied seventy-four-seat Bristol VRT 5533, EWS741W, which displayed a colour bus advertisement for Anchor Butter between August 1983 and August 1985. (*Alan Walker*)

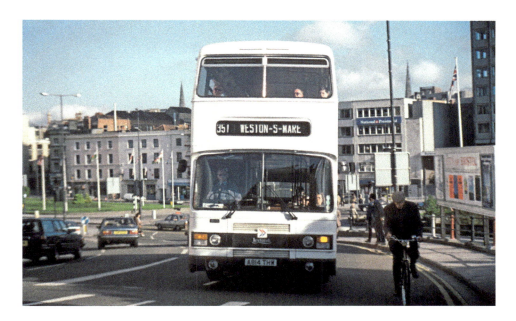

The company received six Roe-bodied Leyland Olympian seventy-six-seat convertible open-top buses in 1984 for service on Weston-super-Mare seafront: all were new in all-over white. 8614, A814THW, which received the name *The Flying Dutchman*, pulls into the College Green central Bristol stop on the way to its seaside home in November of 1984. (*Alan Walker*)

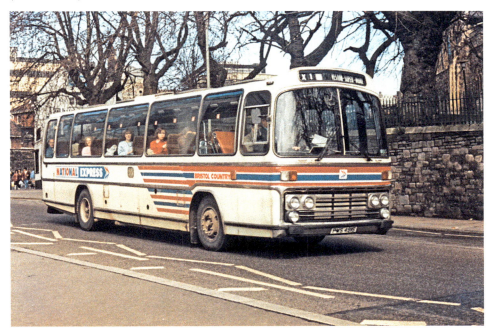

Plaxton-bodied forty-nine-seat Leyland Leopard coach 2187, PWS491S, was renumbered 2310 in 1979 and 2097 in 1981, receiving National Express livery in 1984. It is shown here operating the X1 limited stop service to Weston-super-Mare from Bristol bus station. (*BVBG*)

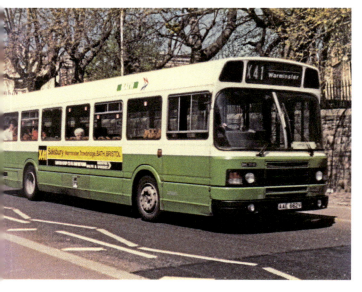

The 1983 introduction of the limited-stop X41 service between Bristol and Salisbury prompted the company to fit a number of Leyland National 2 buses with dual-purpose seats and paint them into a lighter livery. 1980-built forty-seven-seat AAE662V, 3518, leaves Bristol for Warminster, as Salisbury was reached only on alternate journeys. (*BVBG*)

The Plaxton body on 1977 Leyland Leopard coach 2188, PWS492S, was destroyed by fire and replaced with this Plaxton Paramount body in 1983. As 2098, the coach was painted for the ExpressWest group of routes, which had replaced the Bristol–Cardiff service, but had extended Bristol's operation as far west as Haverfordwest! The coach is shown here in Swansea. (*BVBG*)

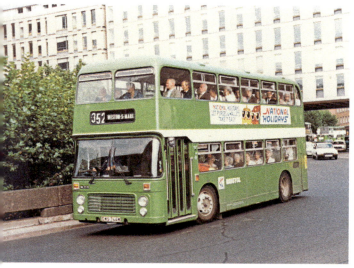

1980 ECW seventy-four-seat Bristol VRT 5536, EWS744W, is fully laden as it rounds St James Barton roundabout, heading for Weston-super-Mare. (*BVBG*)

Managed from September 1983 as a separate business to Bristol city services, the Bristol country bus network, including the depots at Bath, Weston-super-Mare and Wells, were relaunched as Badgerline in April 1985, with a new livery style. The press launch took place at Bristol Airport, as shown by this line up of newly painted Badgerline vehicles. (*Mike Walker*)

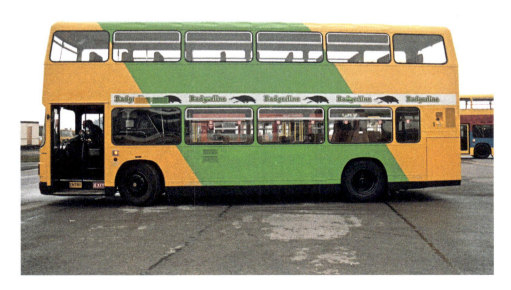

A side view of the new Badgerline livery on a Roe-bodied Leyland Olympian at the Bristol Airport launch: the bus is still to receive its local fleet name. This bus, along with a number of other Olympians, had been retrofitted with more comfortable coach seats. (*Mike Walker*)

Badgerline became well known for the operation of minibuses on high-frequency town services, but the first minibus service was launched in Midsomer Norton/Radstock in April 1985 with two buses on local services. B430WTC is shown here with the two local drivers, Les Gale and Norman Hills, together with Fred Spencer, acting District Manager, who after war service had joined the Tramways company at Weston-super-Mare as a conductor. Like many of the company's minibuses, 4430 was a Dormobile-bodied sixteen-seat Ford Transit. (*Mike Walker*)

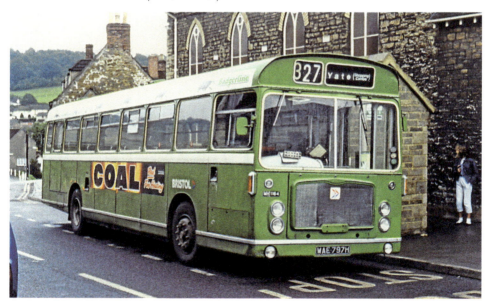

1970-built ECW-bodied Bristol RELL6L WAE797H, 1164, was new as a BJS bus but was transferred to country services and rebuilt to single doorway, eventually becoming part of the Badgerline fleet. In August 1985 the bus is shown at Wotton-under-Edge on its way to Yate: the Badgerline stickers can be seen on the roof, together with the National Bus Company fleet name. (*Phil Sposito*)

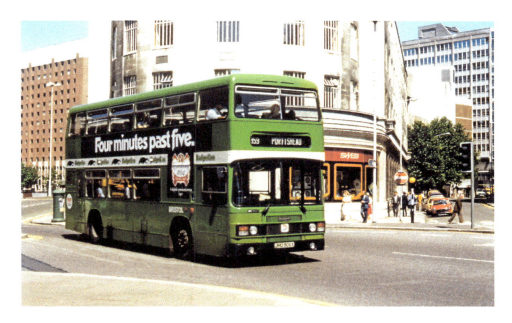

In September 1985, Roe-bodied Leyland Olympian 9507, JHU906X, now fitted with more comfortable coach seats, enters Bristol's centre on its way to Portishead. The between-deck vinyl stickers identified the Badgerline livery before repainting could take place. (*Phil Sposito*)

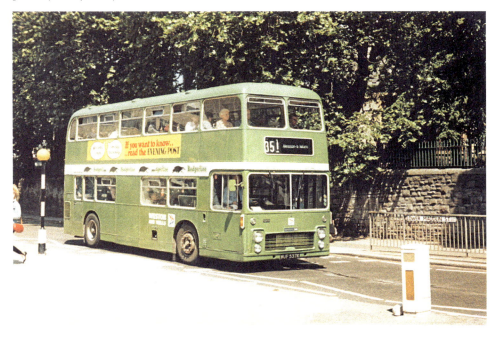

In 1982 the company acquired a batch of ten dual-door ECW-bodied Bristol VRTs from the Southdown company for city services. Surprisingly, 5209, WUF537K, migrated to the country fleet and to Badgerline. As it leaves Bristol's bus station for Weston-super-Mare, the fleet name identifies the fact that it is returning to its home depot. (*BVBG*)

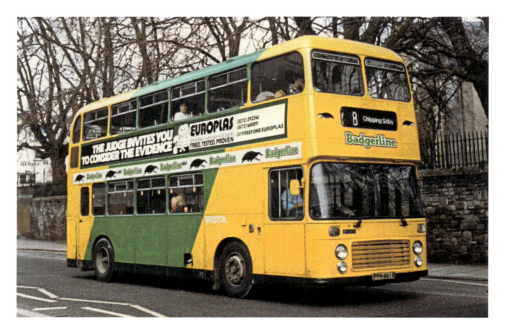

On 1 January 1986 Badgerline became a separate limited company, although there was little outward change to the fleet. Former London Country ECW-bodied high Bristol VRT 6500, PPH461R, shows off the new livery and depot-identifying fleetname, BRISTOL. Leaving Bristol's bus station, the bus is on its way to Yate on limited-stop service X8. (*BVBG*)

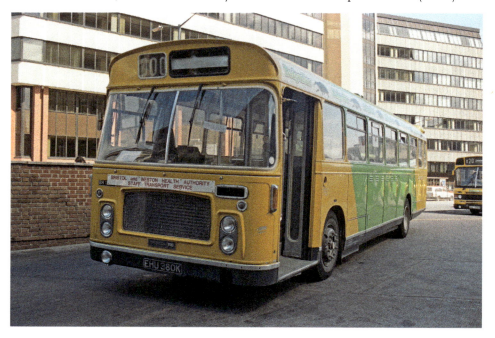

Badgerline in Bristol had an arrangement to supply and maintain a bus for the local health authority for staff transport. 1279, EHU380K, was the 1972 ECW-bodied Bristol RELL6L, which is being used for this purpose in 1986. (*Mike Walker*)

Right: Dual-purpose vehicles in the Badgerline fleet received a brighter livery and the branding 'Swift Link'. Former coach ROU349S, 2191, a 1978 Plaxton-bodied Leyland Leopard, became 2314 in 1979, and 2101 in 1981 and is shown standing at Bristol's Temple Meads station. The friendly badger logo allows the new company to be easily identified. (*Mike Walker*)

Below: The Badgerline company continued the Bristol company's tradition of running bus services to the Glastonbury (Pilton) Festival in June of each year. In 1986 this line-up of ECW-bodied Bristol VRTs, headed by former London Country high bus 6516, PPH462R, loads at the festival for Bath or Bristol. 6516 was renumbered from 6501 so as to avoid confusion with second-hand VR 5601, a low-height bus, as such confusion could have resulted in the roof being removed! (*Mike Walker*)

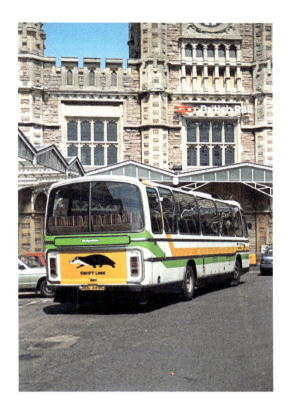

Bibliography

Allan, Ian, *ABC Bristol* (London, from 1949 to 1966).

Bristol Tramways & Carriage Company/Bristol Omnibus Company timetables.

Curtis, Martin S. & Walker, Mike, *Bristol Omnibus Services: The Green Years* (Millstream Books: Bath, 2007).

Omnibus, staff magazine of Bristol Tramways/Bristol Omnibus, 1954–1972.

PSV Circle/Omnibus Society, *Fleet History of the Bristol Tramways & Carriage Company Limited, Bristol Omnibus Company Limited and Badgerline Limited*.

Walker, Mike, *Bristol City Buses* (Amberley Publishing: Stroud, 2014).